AN INTRODUCTION TO ICONOGRAPHY

Documenting the Image

A series edited by
Helene E. Roberts, *Dartmouth College, USA,* and Brent Maddox,
J. Paul Getty Center, USA

Documenting the Image describes the history, influences, and implications of visual artifacts. Its goals include publishing monographs and reference books that promote visual collections around the world.

Volume 1
An Introduction to Iconography
Roelof van Straten

Volume 2
The Public Monument: Inquiries into Its Origins and Its Meanings
Edited by Donald M. Reynolds

Volume 3
Art History through the Camera's Lens
Edited by Helene E. Roberts

Additional Titles Forthcoming

This book is part of a series. The publisher will accept continuation orders which may be cancelled at any time and which provide for automatic billing and shipping of each title in the series upon publication. Please write for details.

AN INTRODUCTION TO ICONOGRAPHY

ROELOF VAN STRATEN

REVISED ENGLISH EDITION

Translated from the German by
Patricia de Man

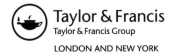
LONDON AND NEW YORK

Copyright © 1994 OPA (Overseas Publishers Association) N.V. Published by license under the Taylor & Francis imprint.

All rights reserved.

First published in English 1994
Second printing 2000

By Taylor & Francis
2 Park Square, Milton Park, Abingdon, Oxon, OX14 4RN
270 Madison Ave, New York NY 10016

Transferred to Digital Printing 2007

Originally published in Dutch in 1985, revised edition published in 1991, as *INLEIDING IN DE ICONOGRAFIE* by Coutinho B.V., Muiderberg, The Netherlands.
Copyright © 1985 by Coutinho B.V., Muiderberg, The Netherlands.

Published in German in 1989 as *EINFÜHRUNG IN DIE IKONOGRAPHIE* by Dietrich Reimer Verlag, Berlin, Federal Republic of Germany.
Copyright © 1989 by Dietrich Reimer Verlag, Berlin, Federal Republic of Germany.

No part of this book may be reproduced or utilized in any form or by any means, electronic or mechanical, including photocopying and recording, or by any information storage or retrieval system, without permission in writing from the publisher.

Library of Congress Cataloguing-in-Publication Data

Straten, Roelof van.
 [Inleiding in de iconografie. English]
 An Introduction to iconography / Roelof van Straten ; translated by Patricia de Man. — Rev. ed.
 p. cm. — (Documenting the image, ISSN 1068-6894 ; v.1)
 Originally presented as the author's thesis (doctoral—Leiden).
 Includes bibliographical references and index.
 ISBN 2-88124-601-X (softcover)
 1. Art—Themes, motives. 2. Art—Historiography. I. Title.
II. Series.
N7565.S7713 1993
704.9—dc20 93-23373
 CIP

Publisher's Note
The publisher has gone to great lengths to ensure the quality of this reprint but points out that some imperfections in the original may be apparent

The idea is a sign of things,
and the image is sign of the idea,
sign of a sign.

Umberto Eco, *The Name of the Rose*

CONTENTS

Introduction to the Series .. ix

List of Illustrations .. xi

Preface ... xvii

Introduction ... xix

THEORETICAL SECTION

1. What Is Iconography? ... 3

2. Personification ... 25

3. Allegory .. 37

4. Symbols, Attributes, and Symbolic Representations 45

PRACTICAL SECTION

5. Literary Sources of Subjects in Art 75

6. Iconographic Handbooks and Photo Archives 101

7. ICONCLASS: A New Method of Research in Iconography ... 117

APPENDIX

An Overview of the ICONCLASS System 145

Index .. 149

INTRODUCTION TO THE SERIES

Documenting the Image is devoted to describing the history, process, and use of visual documents. As many events and most artifacts are known and studied through images made of them, the study of the creation, collection, and use of these images becomes crucial to our understanding of the originals. *Documenting the Image* will provide an arena for discussion of the influence of visual documentation on culture, academic disciplines, and ways of thinking. It will inquire into how visual language is structured and how visual meaning is communicated. It will explore the visual documentation of artifacts through drawings, casts, facsimiles, engravings, and photography, and it will describe the effects of the new electronic technology on visual resources. Through the publication of catalogs of visual materials, it will seek to make these collections better known and more accessible to a wide range of potential users. In addition, the series will provide reference tools which support the description, organization, and use of visual collections.

ILLUSTRATIONS

1. Jan Vermeer van Delft (1632–1675), *A Lady Weighing Gold.* Painting, ca.1664, oil on canvas, 42.5 x 38 cm. National Gallery of Art, Washington.

2. Lucas van Leyden (ca.1489–1533), *The Last Judgment.* Center panel of a triptych. Painting, oil on panel, ca.300 x ca.215 cm. Stedelijk Museum de Lakenhal, Leiden.

3. Adriaen Collaert (ca.1560–1618) after Maerten de Vos (1532–1603), *The Last Judgment* (from a Credo–series). Copper engraving, Rijksbureau voor Kunsthistorische Documentatie (R.K.D.), The Hague.

4. Pieter de Hoogh (1629–ca.1684), *Woman Weighing Gold.* Painting, oil on canvas, 61 x 53 cm. Staatliche Museen Preußischer Kulturbesitz, Gemäldegalerie, Berlin.

5. Lucas van Leyden (ca.1489–1533), *Prudencia.* Copper engraving, 1530, 16.6 x 11 cm. Prentenkabinet der Rijksuniversiteit, Leiden.

6. Anonymous engraver, *Portrait of Cesare Ripa.* From the *Iconologia*, Padua 1624.

7. Christoffel Jeghers (1596–ca.1653), *Verità.* Woodcut, 8.4 x 5.9 cm. From the *Iconologia . . .*, Amsterdam 1644, p. 589.

8. Jan Vermeer van Delft (1632–1675), *The Personification of Faith.* Painting, ca.1673, oil on canvas, 113 x 88 cm. The Metropolitan Museum of Art, New York.

9. Giovanni Domenico Cerrini (1609–1681), *Time Revealing Truth* (counterpart to *Time Abducting Beauty*). Painting, oil on canvas, 127.5 x 170.5 cm. Staatliche Kunstsammlungen, Gemäldegalerie, Kassel.

10. Otto van Veen (1556–1629), *Peace and Justice Kissing.* Painting, ca.1600, oil on panel, 106 x 79 cm. Gemäldegalerie, Augsburg.

xii ILLUSTRATIONS

11. Theodoor Boeyermans (1620–1678), *Antwerp as Patroness of the Fine Arts*. Painting, oil on canvas, 188 x 454 cm. Koninklijk Museum voor Schone Kunsten, Antwerp.

12. Hiëronymus Cock (ca.1510–1570) after Maerten van Heemskerck (1498–1574), *The Triumph of Peace* (from a series). Copper engraving. Prentenkabinet der Rijksuniversiteit, Leiden.

13. Peter Paul Rubens (1577–1640), *The Arrival of Maria de'Medici in Marseilles* (from a series). Painting, oil on canvas, 394 x 295 cm. Musée du Louvre, Paris.

14. Lucas van Leyden (ca.1489–1533), *Man with a Skull*. Copper engraving, ca.1520, 18.5 x 14.5 cm. Prentenkabinet der Rijksuniversiteit, Leiden.

15. Hans Holbein the Elder? (ca.1460–1524), *The Crucifixion*. Painting. Gemäldegalerie, Pommersfelden.

16. Matthias Grünewald (ca.1460–1526), *Saint Lawrence*. Grisaille, panel, 99 x 43 cm. Städelsches Institut, Frankfurt am Main.

17. Francesco Zurbaran (1598–1665), *Saint Agatha*. Painting, oil, 127 x 60 cm. Musée Fabre, Montpellier.

18. Netherlandish (?) master, ca.1490, *The Annunciation*. Center panel of a triptych. Painting, oil on panel, 46.2 x 34.2 cm. Universitätsmuseum, Marburg an der Lahn.

19. Monogrammist AB (active ca.1520), *Portrait of a Young Woman as Lucretia*. Painting, oil on panel, 48 x 31 cm. Gemäldegalerie, Pommersfelden.

20. N. L. Peschier (active ca.1660), *"Vanitas" Still Life*. Painting, oil on canvas, 57 x 70 cm. Rijksmuseum, Amsterdam.

21. Francesco Ubertini "Il Bacchiaccha" (1494–1557), *Portrait of a Cleric with a Skull* (Pope Hadrian VI?). Painting, oil on panel, 98.2 x 73.3 cm. Staatliche Kunstsammlungen, Gemäldegalerie, Kassel.

22. Isack Elyas (active ca.1620), *Cheerful Social Gathering*. Painting, oil on panel, 47 x 63 cm. Rijksmuseum, Amsterdam.

ILLUSTRATIONS xiii

23. Johan de Brune, *Emblemata of Zinne-werck* . . . , Amsterdam 1624, 143.

24. Albrecht Dürer (1471–1528), Detail from the *Great Arch of Triumph*. Woodcut. Prentenkabinet der Rijksuniversiteit, Leiden.

25. Andrea Alciati, *Emblematum Liber* . . . , Augsburg 1532².

26. Andrea Alciati, *Emblematum Libellus* . . . , Paris 1542, 94.

27. Jacob Cats, *Emblemata moralia et aeconomica*, Rotterdam 1627, Emblem 41.

28. Gabriel Rollenhagen, *Selectorum Emblematum* . . . , Utrecht 1613, 95.

29. Otto van Veen (Vaenius), *Amorum Emblemata* . . . , Antwerp 1608, 89.

30. Roemer Visscher, *Sinne-poppen*, Amsterdam 1614, Emblem 12.

31. Page from a *Biblia Pauperum*, Dutch block-printed book, ca.1450.

32. Lucas Cranach the Elder (1472–1553), *Adam and Eve*. Woodcut, Prentenkabinet der Rijksuniversiteit, Leiden.

33. Lambert Ryckx (active 1543–1572), *Susannah Bathing*. Drawing, 1543. Staatliche Graphische Sammlung, München.

34. Jan Cossiers (1600–1671), *The Adoration of the Shepherds*. Painting, oil on canvas, 165.5 x 191 cm. Staatliche Kunstsammlungen, Gemäldegalerie, Kassel.

35. Jörg Stöcker (active 1481–1525), *The Adoration of the Magi*. Painting (section of an altar piece), panel. Cathedral, Augsburg.

36. School of Jan van Scorel (1495–1562), *The Baptism of Christ*. Painting, oil on panel, 64 x 91 cm. Rijksmuseum, Amsterdam.

37. Hans Baldung Grien (1475–1545), *The Crucifixion*. Painting, 1512, panel. 151 x 104 cm. Staatliche Museen Preußischer Kulturbesitz, Gemäldegalerie, Berlin.

38. Lucas Cranach the Elder (1472–1553), *St. Jerome*. Painting, oil on panel, 38 x 28 cm. Gemäldegalerie, Augsburg.

xiv ILLUSTRATIONS

39. David Teniers II (1610–1690), *The Temptation of St. Anthony.* Painting, oil on panel, 31 x 23 cm. Rijksmuseum, Amsterdam.

40. Mateo Cerezo (ca.1626–1666), *Mary Magdalene.* Painting, 1661, oil on canvas, 103.2 x 83 cm. Rijksmuseum, Amsterdam.

41. Willem van Mieris (1662–1747), *Ulysses and Nausicaa.* Drawing. Location and collection unknown.

42. Vicinity of Jan van Scorel (1495–1562) after Raphael (1483–1530), *Burning Troy.* Painting, panel, 43 x 31.5 cm. Centraal Museum, Utrecht.

43. Dutch master (sixteenth century), *The Metamorphosis of Actaeon.* Drawing, ϕ 14.8 cm. Georg–August University, Göttingen.

44. Jacob Frey the Elder (1681–1752) after Francesco Albani (1578–1660), *The Rape of Europa.* Copper engraving. Prentenkabinet der Rijksuniversiteit, Leiden.

45. Anthony van Blockland (1532–1583), *Venus and Adonis.* Drawing. Prentenkabinet der Rijksuniversiteit, Leiden.

46. Johann Rottenhammer (1564–1623), *The Judgment of Paris.* Painting, oil on copper, 19 x 24 cm. Gemäldegalerie, Pommersfelden.

47. Lucas Cranach the Elder (1472–1553), *Lucretia.* Painting, oil on panel, 85 x 57.5 cm. Musée des Beaux–Arts, Besançon.

48. Pieter de Jode II (1606–after 1674) after Anthony van Dyck (1599–1641), *Rinaldo and Armida.* Copper engraving. Prentenkabinet der Rijksuniversiteit, Leiden.

49. Henkel-Schöne, *Emblemata*, columns 1441–1442.

50. Kirschbaum, *Lexikon*, Vol. VIII, columns 59–60.

51. Tervarent, *Attributs et symboles*, columns 309–310.

52. ICONCLASS, *System 7*, Amsterdam 1981, 225.

53. Lucas van Leyden (ca.1489–1533), *The Flagellation of Christ.* Copper-engraving, 11.5 x 7.6 cm. Prentenkabinet der Rijksuniversiteit, Leiden.

ILLUSTRATIONS xv

54. ICONCLASS, *General Alphabetical Index* A–E, Amsterdam 1985, 530.

55. Jan de Bray (ca.1627–1697), *Judith and Holofernes*. Painting, oil on panel, 40 x 32.5 cm. Rijksmuseum, Amsterdam.

56. ICONCLASS, *Bibliography* 7, Amsterdam 1980, 239.

57. Albrecht Dürer (1471–1528), *Madonna Crowned by Angels*. Copper-engraving, 1518, 14.8 x 10 cm. Prentenkabinet der Rijksuniversiteit, Leiden.

58. Unknown master, *The Judgment of Moses*. Private collection?, Berlin?

59. *D.I.A.L.* Photo card.

60. *Marburger Index* Microfiche.

61. *ICONCLASS Indexes: Italian Prints*, volume 2: *Marcantonio Raimondi and His School*, [Doornspijk 1988], 471.

Photographic Acknowledgements

Numbers refer to illustration numbers.

Amsterdam, Rijksmuseum 20, 22, 36–40, 55; Antwerp, Koninklijk Museum voor Schone Kunsten 11; The Hague, Rijksbureau voor Kunsthistorische Documentatie 3; Leiden, Prentenkabinet der Rijksuniversiteit 5, 12, 14, 24, 32, 41, 44, 45, 48, 53, 57; Leiden, Stedelijk Museum de Lakenhal 2; Marburg an der Lahn, Bildarchiv Foto Marburg 4, 9–10, 13, 15–19, 21, 33–35, 37–38, 43, 46 and 47, 58; New York, The Metropolitan Museum of Art 8; Utrecht, Centraal Museum 42; Utrecht, Kunsthistorisch Instituut der Rijksuniversiteit 6; Washington, National Gallery of Art 1.

PREFACE

Originally, I wrote this book as a doctoral dissertation, concluding my study of art history and archaeology at the University of Leiden, The Netherlands.

Following its success in Holland and Germany, predominantly as a university course-book, I am very glad that an English translation now is available.

In England and the United States, a great interest in iconography developed after World War II, stimulated by a number of German scholars who had fled from Germany before 1940, such as Erwin Panofsky and Ernst H. Gombrich. I hope that the present book conveys more recent developments in iconography.

For her enormous help and encouragement, my greatest thanks to Helene E. Roberts. For their assistance and cooperation, I am most grateful to the publishers and, in particular, to Patricia de Man, who translated this volume from the German.

INTRODUCTION

Despite the fact that iconography — the study of themes, objects, and subjects in the visual arts — is one of the main branches of art history, there is still no general introduction to it. The aim of this book is therefore to describe the fundamentals of iconography to students of art history, as well as to art historians and cultural historians.

The first, theoretical part of this book is divided into four chapters. The first chapter answers the question, "What is iconography?" while the other three chapters deal with several concepts frequently used within iconography, "personification," "allegory," and "symbols." Each chapter contains definitions, examples, a short historical abstract, and bibliographic references that enable the reader to orient himself further.

It is not always possible to give precise definitions of the concepts dealt with in this book. It is certainly possible, therefore, that criticisms will now and then arise. I hope, nevertheless, that my descriptions will clarify what we understand, or could understand, by these art-historical terms. I am also aware that many problems are more complex than their representations here.

The second part of the book is directed more towards practical questions: "Which literary sources were often used by the artists?" "What are the most important iconographic handbooks?" "What is ICONCLASS and what practical possibilities does this publication open up for iconographic investigations?"

I will attempt to give conclusive answers to these questions. I have essentially limited myself to Western art from the sixteenth to the eighteenth centuries, since many students, during the course of their studies, are concerned mainly with iconographic problems of this period.

THEORETICAL SECTION

1. WHAT IS ICONOGRAPHY?

When one confronts a work of art, several questions may come to mind. Probably the first and most obvious question is "Who is the artist?" Art history has always concerned itself with attributing certain works of art to particular artists, and in the course of time most parts of the answer to the question "who made what?" fall into place.

Independent of the first stock question is a second, "What does the work of art depict?" or, more precisely, "What is the theme or subject of this work of art?" There has arisen a field within art history that is exclusively concerned with answering this question: iconography. To define the term more clearly, we can say that iconography is the branch of art history concerned with the themes in the visual arts and their deeper meanings or content. The word *themes* should be understood in a broad sense. Iconography considers a representation both as a whole and as a collection of details. For this reason, the meaning of a half-peeled lemon in a seventeenth-century Dutch still life could very well be the theme of an iconographic study. By "deeper meanings or content," we mean other aspects of a work of art that, we may assume, were expressly included by the artist. These references to visual and literary sources and allusions to cultural, social, and historical facts will become clearer during the course of this chapter.

Iconography is derived from the Greek words, *eikon* and *graphein,* that is "image" and "writing." Therefore, translated literally, iconography means "imagewriting" or "image describing." Iconography, then, is not primarily concerned with the attribution of works of art or with their dating. While an iconographic analysis occasionally facilitates a precise dating or an attribution, iconographers usually leave such problems to other art historians. They also tend to avoid judging a work's aesthetic value. Every image—whether in folk art or Art with a capital A—is of equal significance in an iconographic investigation. Questions of attribution and aesthetics are subordinate to the iconographer's real objectives.

The first and most important of these objectives is to determine what is depicted in an artwork and to reveal and explain the deeper

meanings intended by the artist. A second, intermediary concern involves tracking down the direct and indirect sources—both literary and visual—used by the artist. A further area of iconography is the investigation of certain pictorial themes, especially their development, traditions, and content through the ages.

In a work of art, one can distinguish three levels of meaning which simultaneously represent three stages or phases of iconographic research. The first level or phase is the exact enumeration of everything that can be seen in the work of art without defining the relationships between things. The "theme" or "subject" (the things that we see, brought into relation with one another) form the second level of meaning. The third level is the deeper meaning or content of the work of art as intended by the artist. These three levels of meaning or phases of investigation are called, respectively, the *pre-iconographical description*, the *iconographical description*, and the *iconographical interpretation*.

In addition to the three iconographic levels of meaning, we may distinguish a fourth level or phase, which we may designate as the *iconological interpretation*. It is the task of iconology to look beyond queries about artist and subject to a third question: "Why was it created?" or, more precisely, "Why was it created just so?" With the help of the three iconographical phases and the iconological phase, we can define which tools are necessary for an iconographic—and, to a lesser extent, iconologic—investigation.

First Phase: The Pre-Iconographical Description

When we look at a picture for the first time, we automatically make a mental tally of everything that it portrays. Let us consider, for example, Jan Vermeer's *A Lady Weighing Gold* (figure 1). We see a woman, in an interior space, standing by a table. She holds a small balance in her right hand, while her left hand rests on the table. Her noticeably large abdomen seems to indicate that she is pregnant. On top of the table is a small box containing gold weights, a jewel-box with pearl necklaces, and several coins. On the wall in the background hangs a picture, and across from the woman there is another framed object, probably a mirror. The curtain is pulled shut, and the room is filled by an unusual,

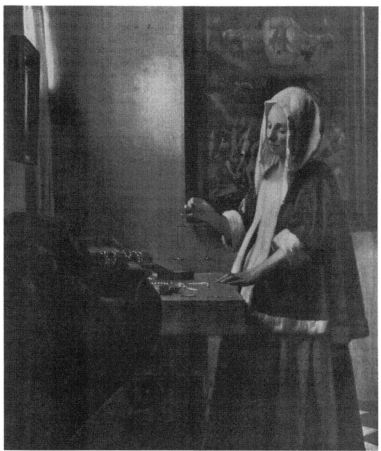

1 A Lady Weighing Gold. Painting by Jan Vermeer.

transfigured light.

This examination brings us to a rather rough enumeration of the "objects" and the situation in the picture. Without attempting to place things in relation to one another or to interpret them, we have drawn a pre-iconographical description.

When studying representative art, it is usually not difficult to produce such a description. In general, we can describe the things and situ-

ations in a work because of their resemblance to the things and situations that surround us. We should always keep in mind, however, that the current meanings of things and situations do not necessarily correspond to those of previous centuries. It is also not always clear what the artist intended. For example, the large stomach of the woman in *A Lady Weighing Gold* could just as well be explained as the seventeenth-century fashion of women wearing cushions on their stomachs.

It is very important to scrutinize a picture carefully while enumerating its contents, for the pre-iconographical description is the prerequisite of every subsequent step toward a correct interpretation. If, for example, the art historian does not notice that the woman's scales in Vermeer's painting are actually empty, which means that she is weighing nothing at all, a subsequent interpretation would have missed the mark. Even such minute details can be of great importance.

One must also address a picture's composition during the pre-iconographical description. For example, in *A Lady Weighing Gold*, which we can now recognize as a misleading title, we should not fail to notice that the woman's head is located exactly in the center of the painting that hangs in the background. The colors that the artist uses may also be of importance and can occasionally have symbolic significance. During the pre-iconographic observation, the stylistic aspects of the visual arts are often neglected, although they are fundamental for the complete understanding and explanation of a work of art (see p. 19).

Second Phase: The Iconographical Description

The purpose of the second iconographic phase is to describe the "subject" of the work of art. As already mentioned, this task is one of the most important in iconography. In order to complete it, one must have an extensive knowledge of the themes and subjects in art, as well as the many ways they have been represented. Because artists have often portrayed the same subjects, there are often several if not many manifestations of most themes. For this reason, portrayals of themes become traditional, with executions of the same subject often resembling one another.

For example, we can compare the center panel of *The Last Judg-*

AN INTRODUCTION TO ICONOGRAPHY

ment, a famous triptych by Lucas van Leyden (figure 2), with an engraving of the same subject by Adriaen Collaert after Maerten de Vos (figure 3). The compositions of these two works—representations of the Last Judgment in which Christ returns to earth in order to judge the living and the dead—are fundamentally the same. This tradition of Last Judgment representations in the visual arts also enables us to recognize the theme of the painting on the wall in the background of *A Lady Weighing Gold*. We may almost assume that without this tradition, the viewer would not be able to recognize the subject of this painting within a painting.

In the course of time, art historians have developed terms that are useful in forming iconographic descriptions. The short descriptions, or titles, in this iconographic idiom often stand for extremely complicated representations. The description "Last Judgment," for instance, implies much more than the two words suggest. Art historians and iconographers in particular must be familiar with these short descriptions and their meanings since they play such an important role in discussions about art.

The range of themes and subjects in art is quite extensive but certainly not limitless. One may procure with relative ease a sound knowledge of frequently depicted subjects by looking through thematically ordered collections of reproductions and by taking care to notice themes and subjects when viewing museum exhibits and reading art-historical literature. In so doing, one learns to recognize the fundamental differences between various thematic areas. For instance, biblical and classical-mythological scenes may be distinguished from each other primarily by settings and by the clothing and accoutrements of their figures.

In this second phase of research we should ideally be able to identify figures and persons. If we succeed, it is easier, on the whole, to identify the subject of the work. However, it should be noted that the identification of personified abstractions is already part of the third phase. More about the identification of persons and figures will follow in the fourth chapter, "Symbols, Attributes, and Symbolic Representations."

A profound knowledge of the themes and subjects in art is absolutely essential in the study of iconography, but a familiarity with literary sources of artworks, such as the Bible, is also an indispensable tool. A piece of literature can be a direct source if the artwork is based on the

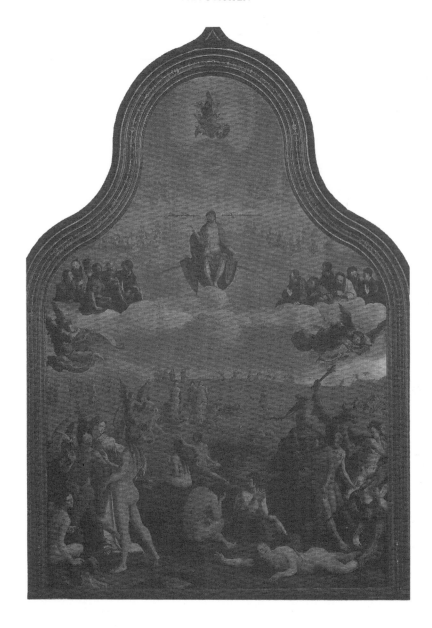

2 The Last Judgment. The subject refers primarily to Matthew 25:31-46. The center panel of a triptych by Lucas van Leyden.

3 The Last Judgment (from a Credo-series). Copper engraving by Adriaen Collaert after Maerten de Vos.

text, or an indirect one if the artist models his work on another work that is in turn based upon a literary source. In the first case, one can expect a more or less exact "pictorial translation" of the text, while in the indirect method, iconographic traditions may play a more important role. Often, of course, artists have been influenced by both literary sources *and* the iconographic tradition. During an iconographic investigation, the iconographer should naturally endeavor to discover which works of art could have influenced the artist.

Prints have always been an important visual source for artists. Their influence is often purely formal: the artist may copy the position of a certain figure, a part of a composition, or even another artist's entire representation. It was once customary for artists to "reproduce" parts of works by other artists; we should not consider it plagiarism. Artists often kept entire collections of prints and drawings from which the master and his students could appropriate various details. The simplest way for modern iconographers to find these visual sources is to work through thematically arranged collections of reproductions and photographs. Materials from some collections of prints have even been arranged, at least in part, according to iconographic criteria.

The most influential literary works are listed in the fifth chapter, "Literary Sources of Subjects in Art." Several important iconographically accessible or iconographically assembled collections of reproductions follow in the sixth and seventh chapters.

Third Phase: The Iconographical Interpretation

The purpose of the third phase of iconographic research is to ask: "Does the work have a 'deeper,' or secondary, meaning that could lie within the artist's intention?" If the answer is yes, then we will have to determine the meaning.

If we say that a representation has a deeper meaning, we usually mean that it conveys an underlying idea that cannot be determined at first glance. Although educated contemporaries of the artist may have instantly understood such a meaning, today it is often quite difficult for art historians to grasp the deeper message. This is especially the case in "genre representations," artworks that are apparently realistic images

of everyday life but often have a hidden, and often moral, meaning, such as Esack Elyas' *Cheerful Social Gathering* (figure 22). The interpretations in this third iconographic phase are almost always of an abstract nature; therefore, the identification of persons and figures embodying abstract concepts, or personifications, belongs in this phase.

What does one need for an iconographic interpretation? Again, the most important tool is a solid knowledge of the secondary or symbolic meanings that an object, situation, certain action, or even an image as a whole may have had in a certain period. We must at least learn to spot the places where these meanings potentially exist.

In Vermeer's *A Lady Weighing Gold* we may, for instance, recognize several particularities that more or less warn the viewer of the picture's deeper meaning. We can make a connection, for example, between the picture of the Last Judgment in the background and the balance that the woman holds, for at the Last Judgment human souls are weighed. But what is the precise connection between the two? And do the pearl necklaces on the table have a specific meaning? These are the sort of questions that should be answered in the third phase of research.

Making a study of the artist's visual and literary sources often leads to a solution. One should try to gather together everything that has been written about the object under investigation. Also useful are art historians' interpretations of other works by the same artist, especially pieces that depict similar objects or situations. Studies of related works by other artists from the same period and locality can be equally helpful. Contemporaries may have inspired each other or been influenced by the same books, events, and ideas.

In the end, experience in observation is essential for iconographic analyses. As modern iconographers, we must accustom ourselves to the metaphorical thinking of past centuries in order to see where and why artists have placed deeper meanings into their works. Finally, we need to think logically and creatively in order to draw the right conclusions and to derive from our research and deductions the most plausible iconographic interpretations.

To make a sound interpretation, one must avoid several common pitfalls. Many art historians incorporate only those elements of a representation that support their interpretations, ignoring other, perhaps conflicting, details within the same work. In a good interpretation, how-

ever, all visible aspects are considered. Conversely, one must avoid the danger of over-interpreting pictures. One way to avoid such errors is by engaging in highly critical readings of interpretations by other authors. An effective argument should make extensive use of literary sources, comparable works of art and their interpretations, and other criteria.

Iconology

Iconology has already been described as a sort of fourth phase. We can define iconology as the branch of cultural history that uncovers the cultural, social, and historical background of themes and subjects in the visual arts. By means of this background, iconology can explain why an artist or patron chose a particular subject at a specific location and time and represented it in a certain way. An iconological investigation should concentrate on the social-historical, not art-historical, influences and values that the artist might not have consciously brought into play but are nevertheless present. The investigator asks how social developments are reflected in the visual arts. Through such an approach, the artwork appears as a document of its time. In a narrower sense, however, the artwork can also emerge as a personal record of the artist or, in certain cases, the patron.

Scientific, social, religious, literary, and philosophical developments are fundamental to iconological interpretations. These considerations suggest that historians, cultural historians in particular, are best prepared for an iconological investigation. But iconological interpretations must be made on the basis of iconographic investigations, for which the cultural historian is not trained. It is here, therefore, that art history and cultural hisory touch and should complement one another. Art historians concerned with iconology should be aware of their eventual insufficiencies and be prepared to use cultural historical methods in this phase of research. Until now there has not been a widely used iconologic method of investigation.

Some examples of typical iconologic questions are "Why did Caravaggio depict the drunken Bacchus precisely in the manner he did?" or "Why was the Suicide of Lucretia theme (see figures 19 and 47) so

popular in the sixteenth century?" One can also turn the question around to ask why a certain subject, in a certain location, at certain point of time, does not appear anymore. Theoretically, at least, it is always possible to present an iconological argument about a work of art, even if an iconographic interpretation is impossible. For the most part, iconology, as defined here, remains undeveloped, and art historical publications with iconological orientations are few.

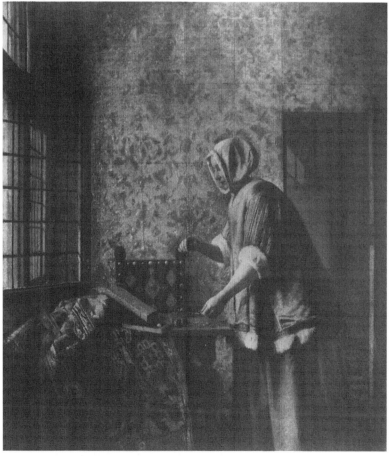

4 A Woman Weighing Gold. Painting by Pieter de Hoogh.

Iconography and Iconology: A Differentiation

It is perhaps appropriate now to examine some of the details of iconographic interpretations more closely. For this purpose, we will again use Vermeer's painting (figure 1) as a point of departure and will briefly demonstrate the iconographic phases as they are schematically outlined in diagram 1.

We have already discussed the pre-iconographical description of the picture. The iconographical description, where one combines the individual elements of the first phase, should finally lead to the specification of the subject matter or theme of the representation—in this case to the iconographic theme of *A Lady Weighing Gold*. It becomes clear that more can be found in this painting than what appears at first glance when we compare it to a picture made only a few years later by Pieter de Hoogh, *Woman Weighing Gold* (figure 4). In the case of the Vermeer, not only is the woman holding empty scales, but there is not even a suggestion of movement or action. In de Hoogh's picture, however, one can see that the woman is actually weighing something. Moreover, there is the conspicuous picture of the Last Judgment in the background of *A Lady Weighing Gold*. These details warn the iconographer that Vermeer's work requires an iconographic interpretation. In concentrating on the details, we will assume that the enlarged abdomen of the woman is a phenomenon of fashion, an assessment with which costume experts agree.

One of the first critics to write about the iconography of *A Lady Weighing Gold* was Herbert Rudolph in his article "Vanitas."[1] He dwells on the connection between the picture of the Last Judgment and the woman, and he mentions that the scales are empty. Rudolph interprets the picture as a representation of the transitoriness of human life, or *Vanitas*, by means of the valuable jewelry on the table and the mirror on the wall. Jewelry and mirrors are often used as symbols of ephemerality in the visual arts.

Approximately forty years later, Svetlana Alpers published an entirely new interpretation of *A Lady Weighing Gold* in her article "Describe or Narrate?"[2] Refuting the *vanitas* interpretation, she explains the woman with the balance as a representation or personification of Justice. She concludes that the woman must be seen as "the kind of

justice (justness) possible on this earth, in the Dutch home, of the woman."

Arguments can be made for and against both interpretations. There are, in fact, *vanitas* elements in the picture, and there is also a reference to Justice, since the scales appear mainly in connection with Justitia, who weighs good and evil with them. But Svetlana Alpers' connection of Justice with the Dutch housewife makes her interpretation problematic, for it keeps her from explaining the picture of the Last Judgment. Furthermore, the entire atmosphere of the picture speaks against such a profane interpretation.

There were several kinds of Justice recognized during the seventeenth century, among them Divine Justice. By what better means could God's Justice be represented than by the Last Judgment? Through the connection between the woman with the balance and the picture in the background, we can explain the peculiar atmosphere in the picture. The woman becomes the visual representation or personification of Divine Justice, and the work's moralizing significance might be summarized as: "You, who are viewing this picture, do not let yourself be distracted by worldly things (the riches on the table), but consider your soul, which will be weighed by the justice of God at the Last Judgment." Vermeer masterfully combines the concepts *vanitas* and Divine Justice, shaping them into the guise of the well-known type of *A Lady Weighing Gold*.

Whether or not this interpretation of *A Lady Weighing Gold* is correct, the process of reaching it clearly illustrates the three phases of iconographic research:

1. *Pre-iconographical description*: The enumeration of what we see: "a woman in an interior space, standing by a table"

2. *Iconographical description*: The picture belongs to the iconographic type of "women weighing gold or money."

3. *Iconographical interpretation*: *A Lady Weighing Gold* is a personification of Divine Justice.

The fourth phase, the *iconological interpretation,* deals with the question of why Vermeer took on this subject and why he represented it in this way.

As long as a work of art is not abstract, one can always divide an

16 Van Straten

Diagram 1

The Phases of Iconography and Iconology

Work of representational art

———————————— Knowledge of the world around us: familiarity with objects, customs, etc.

1. Pre-iconographical Description
Enumerating everything we see in a representation without establishing any relationships or interpretations. Some formal aspects as well, e.g., color.

———————————— Knowledge of themes and subject matter in art, as well as their modes of representation over the centuries; knowledge of the artist's direct and indirect sources.

2. Iconographical Description
Relating the elements of a representation with one another and formulating the theme or subject without attempting to discover a deeper meaning.

———————————— Knowledge of possible secondary meanings and interpretation of the artist's sources.

3. Iconographical Interpretation
Identifying the deeper (also the symbolic) meaning of a representation as explicitly intended by the artist.

———————————— Profound knowledge of the era's cultural-historical character, e.g., politics, religion, state of scholarship, everyday life, etc.

4. Iconological Interpretation
Identifying the deeper contents of a work of art not explicitly intended by the artist but nevertheless incorporated in his work.

iconographical study into three phases. Some examples:

	Phase 1	Phase 2	Phase 3
A	Description	Still Life with Skull	*vanitas*
B	Description	The Judgment of Solomon	Justice
C	Description	Winter Landscape	The month of January
D	Description	Landscape with Farm	No iconographic interpretation
E	Description	Two Boys Blowing Soap Bubbles	*vanitas*
F	Description	The Suicide of Lucretia	Virtue

In diagram 1 the schematic division is theoretical; boundaries between the individual phases are actually fluid and divisions into phases often superfluous. For example, the content or the deeper meaning of a representation, properly the result of phase 3, sometimes emerges from the literary source used by the artist, which is usually researched in phase 2. In addition, an iconographical interpretation is frequently impossible, as in example D above. In the case of portraits and landscapes, the third phase is usually inapplicable. But still lifes, genre paintings, and artworks based on literary sources often have deeper meanings and can be interpreted iconographically. We should therefore always consider the third phase to make certain that an iconographical interpretation is truly impossible.

The fact that one frequently uses cultural-historical data for iconographical interpretations does not mean that one has proceeded into iconological territory, since the questions posed during the iconographical phase are entirely different. In addition, the impossibility of an iconographical interpretation does not rule out an iconological explication. As we have noted, in theory an iconological interpretation is always possible.

Our division of iconography and iconology into four phases comes from the traditional scheme of three phases developed by Erwin Panofsky (1892–1968). The first phase of Panofsky's scheme is the "pre-iconographical description," which corresponds with phase 1 of our scheme. The second phase, which Panofsky designates as the "iconographical

analysis," resembles our scheme as well, although Panofsky excludes certain categories of subjects from this phase; our phase includes all subjects.

In 1939 Panofsky called his third and last phase the "iconographical interpretation (in a deeper sense)," but in 1955 he changed its name to the "iconological analysis." Panofsky should have differentiated further by asking two questions, the first art-historical—"What secondary or deeper meaning did the artist intend?"—and the second cultural-historical—"Why has a certain work of art arisen in a particular way; how can it be explained in the context of its cultural, social, and historical backgrounds; and how can the possible hidden meanings that were *not* explicitly intended by the artist be brought to light?"

We can argue that in certain works one cannot always differentiate between conscious and unconscious "symbolic" values. However, in general we can and must differentiate between them. As we have already made clear, there are often details or elements in a work of art that indicate, or "warn" us, that the artist intends to express more than what is recognizable at first glance. Furthermore, consciously added meanings are often expressed by symbols, which can be analyzed and interpreted as such (see chapter 4). And within the iconological context, the work of art appears as a document of its time and sometimes as a document that represents the concerns of the artist himself.

Panofsky does not pay much attention to the difference betweenthe artist's conscious intentions and his work's underlying cultural meanings. Yet one can conclude from the 1939 introduction to his theory that both aspects belong to his third phase. In our schematic representation, Panofsky's "iconological analysis" is subdivided into two phases: the iconographical and the iconological interpretations.

Certain aspects of Panofsky's theory remain unclear and are partly to blame for confusion concerning the use of "iconography" and "iconology" in art-historical terminology. Some have applied the two concepts as if they were interchangeable. In practice one cannot conflate iconography ("image describing") and iconology ("image explaining"). Iconography, as a part of art history, goes far beyond the mere description of a representation. As a discipline, it has a set of tools and aids that make possible the interpretation of representations. Our definitions and delimitations of "iconography" and "iconology" should at least fa-

AN INTRODUCTION TO ICONOGRAPHY 19

cilitate their use.

Finally, we must note that iconography, as it is portrayed here, is not a comprehensive method for studying works of art. It fails to account for stylistic aspects, which strictly speaking form another field of art history. Yet an analysis of a work's stylistic aspects is essential to understanding it. The stylistic-historical approach might best be viewed as a primary phase or as one running partly parallel to the phases of iconography. We should also note that iconological questions go beyond the scope of this book and are addressed only marginally herein.

A Short History of Iconography

The first traces of an iconographic approach to the visual arts appear in ancient Greek literature. There are descriptions of artworks in the writings of Philostratos, though it is not clear whether he is talking about real or fictive works of art. Strictly speaking, there is no real interpretation of art until late in the sixteenth century. The first "genuine" iconographer seems to have been Giovanni Pietro Bellori. In the introduction to his *Vite de' Pittori . . . (Biographies of Artists)*,[3] he asserts that he will pay special attention to the content of artworks and later notes that Nicolas Poussin first drew his attention to the iconographical aspect of pictures. Bellori occasionally describes pictures by attempting to identify their subjects, inquiring after their literary sources, and, finally, searching for deeper meanings.

In the seventeenth and eighteenth centuries, interest in iconography gradually spread. The development is especially recognizable in archaeological studies of classical antiquity. An outstanding example is G.E. Lessing's *Wie die Alten den Tod gebildet (How the Ancients Modeled Death)*,[4] in which the author treats the iconographic theme of "Cupid with the Inverted Torch."

During the nineteenth century, the scholarly pursuit of medieval iconography evolved primarily in France. Inspired by F.A.R. Chateaubriand's *Le génie du Christianisme (The Character of Christianity)*,[5] many studies within this field appeared—by A. Crosnier, A.N. Didron, and C. Rohault de Fleury, among others—producing a representative overview of Christian iconography. Iconographers of the twen-

tieth century, such as J.B. Knipping, K. Künstle, E. Mâle, L. Réau, and J.J.M. Timmers, based their works on ideas first developed by their French predecessors.

At the beginning of this century, Aby Warburg (1866-1929), founder of the Warburg Library in Hamburg (now the Warburg Institute, London), developed a new approach for the iconographical perspective on art. The nineteenth-century French iconographers were mainly interested in analyzing the content of artworks through references to theological literature and the liturgy. Warburg, however, saw the creation of artworks against a much broader background. Familiarity with mythology, science, poetry, history, and the social and political life of the time was, in Warburg's view, inextricably bound together with a correct interpretation of artworks, their themes, and their subjects. Warburg was the originator of what his students later designated as iconology, or the iconological perspective on art.

Warburg had several important followers. Among them was Erwin Panofsky, who became the most significant researcher in the area of iconography and iconology. Panofsky developed Warburg's ideas in a somewhat different direction and devised, as has already been discussed, a theoretical scheme for the iconographical/iconological method of investigation. Despite the many critical remarks made in regard to Panofsky's scheme, one must still regard it as the theoretical basis of iconography and iconology.

Primarily because of Panofsky's publications, iconography has attracted significant attention since the Second World War, while the history of style as a component of art history has diminished in importance. In addition to the many iconographical reference books and numerous essays about special themes and subjects in art, some publications have attempted to make iconographical literature more accessible (see chapter 6). The ICONCLASS system (see chapter 7) gives iconography a solid scientific basis by means of a systematic classification of all pictorial objects and subjects that occur, or could occur, in the visual arts.

Since the beginning of this century, still another approach—semiotics, or the study of signs — has evolved with regard to representations in the visual arts. The term *sign* is understood here in its broadest sense. Language, tone, color, odor, symbols in works of art, and even

artworks themselves are all signs. Semiotics, therefore, finds an application not only in art history, but also in many other fields. In theory, semiotics can be used for the analysis and interpretation of works of art; in practice, however, the results have proved to be limited but not uninteresting. One can therefore assume that iconography and iconology will retain their importance in the study of visual artworks.

Literature for Further Study — Iconography and Iconology

The second, third, and fourth articles mentioned here may also be found in *Bildende Kunst als Zeichensystem I: Ikonographie und Ikonologie*, ed. E. Kaemmerling (Köln 1979). Most of the other articles reprinted in this book are also worth reading for a better understanding of the different definitions of, and opinions about iconography, iconology, symbolism, and the like.

1. E. Panofsky, *Studies in Iconology: Humanistic Themes in the Art of the Renaissance*. New York 1939.

 The "Introductory" of this book is the fundamental text in the theory of iconography and iconology. Panofsky gives an introduction to his method and to his scheme for iconographical research. It is a revised version of his article in *Logos* 21 (1932), 103-19. Several chapters in *Studies in Iconology* are good examples for the practical application of Panofsky's theory.

2. E. Panofsky, "Iconography and Iconology: An Introduction to the Study of Renaissance Art." In Idem, *Meaning in the Visual Arts*. Garden City, NY 1955, 26–41.

 This is another version of the "Introductory" of 1939; nothing essential has been added. The most important difference is the change of the third phase's designation from "iconographical interpretation" to "iconological analysis."

3. J. Bialostocki, "Iconography." In *Dictionary of the History of Ideas*, ed. Ph. P. Wiener. New York 1973, 2: 524-42.

 This is the best article about iconography and iconology, in general, and the history of iconography, specifically. Highly recommended.

4. M. Libman, "Ikonologie." *Kunst und Literatur* 14 (1966), 1228-43.

 Libman discusses Panofsky's theory in detail and makes several critical remarks about the practical application of his scheme.

5. R. Heidt, *Erwin Panofsky: Kunsttheorie und Einzelwerk*. Dissertationen zur Kunstgeschichte 2. Köln 1977.

In the fifth chapter of this book, Heidt deals with Panofsky's scheme and the most important criticism of it (by O. Pächt and L. Dittmann, among others).

6. E.H. Gombrich, "*Icones symbolicae:* Philosophies of Symbolism and Their Bearing on Art." In Idem, *Symbolic Images: Studies in the Art of the Renaissance.* London 1972, 123-91.

In this scholarly essay, Gombrich delves into much that is significant to iconography, such as personification, allegories, emblems, and symbols, as well as Cesare Ripa's *Iconologia.*

7. G. Hermerén, *Representation and Meaning in the Visual Arts: A Study in the Methodology of Iconography and Iconology.* Lund Studies in Philosophy 1. Lund 1969.

This book is of special interest for it clearly shows that art historians differ in their use of terms such as *depict, represent,* and *illustration.* In the last three chapters, Hermerén discusses in detail many aspects that are connected with the theory of iconography; the fifth chapter deals with allegory.

8. U. Eco, *A Theory of Semiotics.* London 1977.

Eco is one of the most important scholars in the area of semiotics today. For a recent state of affairs of semiotics, see M. Bal & N. Bryson, "[Views and overviews], Semiotics and Art History." *The Art Bulletin* 73 (1991), 174-208.

9. R. van Straten, "Panofsky and ICONCLASS." *Artibus et historiae* 13 (1986), 165-81.

A short critical examination of Panofsky's theory, with a well-founded suggestion for a classification of iconography and iconology into four phases, as it is discussed in the present book.

10. O. Bätschmann, *Einführung in die kunstgeschichtliche Hermeneutik: Die Auslegung von Bildern.* Darmstadt 1984.

One should particularly note the third part; on the whole, however, an interesting book.

11. J.K. Eberlein, "*Inhalt und Gehalt: Die ikonographisch-ikonologische Methode.*" In *Kunstgeschichte: Eine Einführung,* ed. H. Belting. Berlin 1986, 164–85.

AN INTRODUCTION TO ICONOGRAPHY

12. Brendan Cassidy, Editor, *Iconography at the Crossroads*. Princeton 1993. Papers from the Colloquium sponsored by the Index of Christian Art, Princeton University, 23-24 March, 1990. Papers of a general nature include the introduction by Brendan Cassidy; "Unwriting Iconology," by Michael Ann Holly; "The Politics of Iconology," by Keith Moxey; and "Iconography as a Humanistic Discipline," by Irving Lavin. The remainder of the articles deal with iconographic interpretations in more specific periods or works of art.

Notes

[1] *Festschrift Wilhelm Pinder*. Leipzig 1938, 405–33.
[2] *New Literary History* 8 (1976), 16–43.
[3] Rome 1672.
[4] Berlin 1769.
[5] Paris 1802.

2. PERSONIFICATION

When an artist wants to represent a human figure, he can simply hire a model or ask a friend to sit in his studio. If he wants to draw a landscape, he can drive out of the city in search of a beautiful view and start drawing in his sketchbook.

Both of these simple (and stereotypical) examples show that reproducing things that really exist poses no problems for the skilled artist. In creating something that his audience can identify as a human figure or a landscape, he can either use models or his imagination. He can also depict scenes or subjects from literature by using his own surroundings as a source of inspiration.

Yet there are also things that artists cannot represent directly, such as abstractions. The human intellect has devised a whole set of ideas and concepts that are neither visible nor tangible, like Love, Greed, Melancholy, and Good Fortune, and artists have sought to transform these abstractions into visual images for the most diverse reasons. Of course, artists have long depicted stories in which intangible concepts play identifiable roles. But such works illustrate abstract ideas in definable contexts rather than represent the ideas in isolation. For that reason, artists found substitutes for the abstractions so they could portray them directly. These substitutes are called *symbols* (which are dealt with in the fourth chapter) and *personifications*.

We can generally define a personification in the visual arts as a human or anthropomorphic figure who represents an abstract idea or concept, such as Prudence in figure 5. Most personifications are female figures because most abstract terms in Latin and Italian have feminine endings. Personifications can be clothed or naked, almost always have objects accompanying them, and might also be surrounded by plants and animals. These ornaments, called *attributes*, have specific meanings and illustrate the characteristics and qualities of the personified abstraction. Apart from attributes, personifications may also have distinctive physical traits, such as the wings of Father Time (see figures 9 and 11). A personification can also be an "allegorical figure" but not an "allegory," as the next chapter will show.

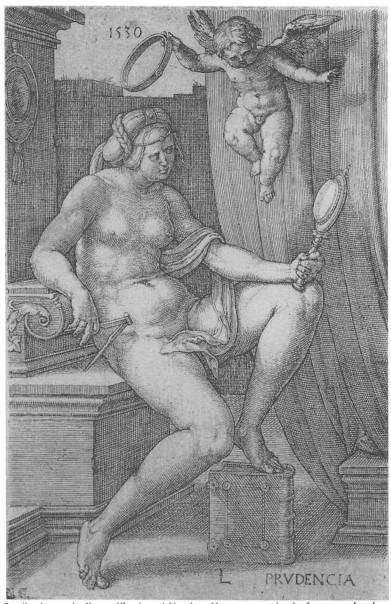

5 Prudence, the Personification of Caution. Copper engraving by Lucas van Leyden.

An Introduction to Iconography 27

Personification is not a modern device. The demonic creatures of the ancient Greeks evolved into gods with unique characteristics, blending divinity and personification. For instance, the Greeks associated the goddess Aphrodite (whom the Romans called Venus) with Fertility and Love; she also personified these concepts.

The Greeks sometimes described personifications in literature so vividly that it is impossible to know whether an author is speaking about a deity, a personification, or an abstract concept. The Greeks also personified tangible—usually natural—things, such as rivers, mountains, and the moon. Regarding these phenomena as living beings, the Greeks believed them capable of being personified.

The Romans appropriated many of the Greeks' gods and personifications, though rarely attaching additional meanings to them. They did create new personifications of cities and provinces, and when they encountered fresh things or ideas, they devised new personifications.

When early Christian artists wanted to express an abstraction they never referred directly to the Roman gods, since Christians could not portray heathen deities. In their personifications Christians nevertheless used the gods' outward appearances. For that reason, when Coelus appears on early Christian sarcophagi we should recognize him as an embodiment of the heavens, not as a classical god.

In the Middle Ages, personifications appeared mainly in literary texts, especially poetry, and were drawn on illuminated pages. The most important example of a literary work that contains personifications is the *Roman de la Rose* (*Romance of the Rose*), written in thirteenth-century France. The association between personification and literature established a tradition in which several aspects of Renaissance thought developed, among them "metaphorical thinking."

During the Middle Ages, personifications in general, and the Roman gods and personifications in particular, became separated from their identifying attributes and characteristics. It is often impossible to identify every personification in medieval book illuminations; we can recognize them only if they have titles or are named in the accompanying text. Except for several typical Christian personifications, such as Ecclesia (the new or Christian Church) and Synagogue (the old or Jewish Church), very few new ones came into being.

Nevertheless, people remained familiar with the gods and personi-

fications despite the loss of their outer characteristics. In the third quarter of the fourteenth century, Giovanni Boccaccio collected everything that was known about the classical gods and published it in his book *De Genealogia Deorum* (*The Genealogy of the Gods*). This mythographic handbook remained popular for almost two centuries. It seems to have had little influence on the visual arts before the second half of the fifteenth century, however, probably because artists and their patrons still lacked a special interest in classical mythology and history. Enthusiasm for the classical age developed only later, during the sixteenth century, when the humanists advocated the study of classical antiquity, especially classical literature, and Roman and Greek relics were unearthed, particularly in Rome.

Attitudes about personifications during the sixteenth century differed completely from those of the Middle Ages. While Boccaccio had used few if any classical artworks—such as reliefs, frescoes, and coins—as sources for his *De Genealogia Deorum*, Renaissance mythographers employed these objects as models. At the same time, artists and their patrons developed an interest in stories about the gods of classical antiquity, and mythographic handbooks became very popular. Vincenzo Cartari's *Le imagini colla sposizione degli dei degli antichi*, which deserves special attention, describes how the gods and personifications were once represented and how they should be depicted anew.[1] Natale Conti's *Mythologiae sive explicationis fabularum* also served as an important handbook for artists.[2] Many personified abstract concepts, having maintained their reputations for centuries of obscurity, regained their original appearances as classical gods and were once again individually recognizable. Embodiments of abstract concepts became so popular that many new ones were "invented." The creation of new personifications became an intellectual game for scholars, artists, and patrons. This sort of "metaphorical thinking," or thinking in abstract terms and symbols, was a legacy of the Middle Ages.

Toward the end of the sixteenth century, the Italian Cesare Ripa published an encyclopedia in which he collected hundreds of personifications and described them comprehensively. The rest of this chapter is devoted to Ripa and his book.

Ripa's *Iconologia*

We know practically nothing about the life of Cesare Ripa (figure 6). Born in Perugia around 1560, he appears to have gone to Rome while a child and later entered the service of Cardinal Antonio Maria Salviati as a *maggiordomo*, or superintendent of the household. During his free time, he dedicated himself to his studies and wrote one of the world's most important books for artists, the *Iconologia*. For numerous painters, graphic artists, and sculptors of the seventeenth and eighteenth centuries, the *Iconologia* presented ways that more than one thousand abstractions should be depicted. In 1593 the first edition was published in Rome without illustrations; the second, again unillustrated, was published in Milan nine years later. In 1603 the third edition, which contained several hundred woodcuts, was published in Rome. Ripa constantly expanded his book by adding personifications; his friend Giovanni Zaratino Castellini continued this task after his death. By the end of the eighteenth century, about twenty editions and revised editions had been published in various languages. The *Iconologia* was what we would call a "best-seller."

Ripa ultimately describes over 1,250 personifications which he either knew or could imagine. They appear in alphabetical order, from *Abondanza* (Plenty, Abundance) to *Zelo* (Zeal, Diligence). He not only relates in extreme detail how personifications should look, but he also explains why they should be depicted precisely as he describes them. The moralizing nature of his "specifications" often becomes evident in these explanations.

Cesare Ripa traveled in the intellectual circles of his day and belonged to at least one literary academy. These associations probably served to awaken his interest in hieroglyphs (Horapollo), emblems (Alciati), and mythographical literature—all rich sources for his personifications. (For hieroglyphs and emblems, see chapter 4.) Visual artworks also function as important models: he borrows from pictures and frescoes by his contemporaries, especially those in the Vatican, as well as classical sculpture, coins, and medals. Since he could not find a precedent for every concept he wanted to personify, he had to invent many personifications. Ripa seldom cites his sources, so it remains unclear which personifications he bases on tradition and which are prod-

6 Portrait of Cesare Ripa, from the *Iconologia*. Padua 1624.

AN INTRODUCTION TO ICONOGRAPHY

ucts of his own invention.

Ripa relies on a single method to construct his personifications, which are always based on the traditional human or anthropomorphic figure. He uses a female figure if the ending of the Italian term to be personified is feminine; for masculine terms he chooses a male figure. If appropriate, he gives the figure a dress or costume in an appropriate color and adds the objects or the plants and animals that become it. Ripa's description of Truth (figure 7) clearly shows the care that he exerts with every consideration and detail:

> A very beautiful, naked woman with her right hand holds up a radiant sun, at which she gazes, and with her other hand clutches an open book and a palm branch; under her right foot she has a heavenly globe. Truth is an ability of a well-disposed mind to deviate the tongue neither from sincerity nor from the nature of those things about which one writes or speaks: asserting only that which is true and denying that which is not true, without changing of mind. She is depicted naked since simplicity is her nature, of which *Euripides* says in his *Phoenissis* that it is very simple to speak the Truth, since she does not need any idle and ornamented explanations.... She holds the sun in order to express that Truth is a friend of light; she herself is a clear light revealing everything as it really is.... The open book means that the Truth of things can be found in books, and therefore the book is the exercise of knowledge or scholarship. The palm branch may express her strength since, as it is generally known, the palm tree yields to no weight, just as Truth yields to no opposing things.... The globe under her foot means that she is higher and more dignified than all the goods of the world, since she is a spiritual entity.[3]

We can infer from the introduction to the *Iconologia* that Ripa does not want his readers (i.e., artists) to make their audiences guess about the identities of the personifications, and he even advises them to include the personifications' names upon occasion. Conversely, though, he wants viewers to wonder why a personification is represented in a particular way and why specific plants, animals, objects, and outward characteristics are associated with it. Evidently viewers were accustomed to solving such "riddles": during festive processions of high-ranking personalities, "living personifications" often accompanied pageants and

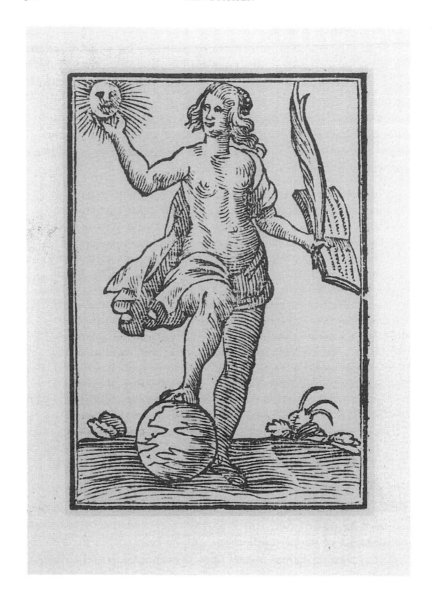

7 Verità, the Personification of Truth. Illustration by Cristoffel Jeghers from the Dutch translation of the *Iconologia*, Amsterdam 1644.

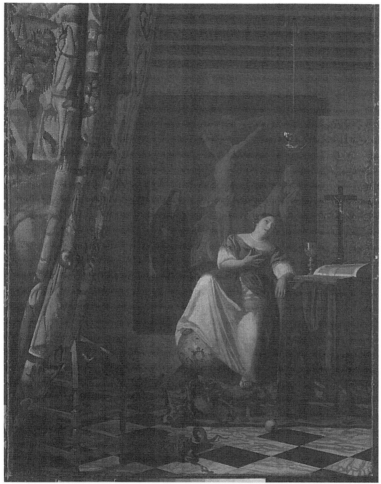

8 The Personification of Faith, based on Ripa's description. Painting by Jan Vermeer.

occasionally wore "name plates" to identify the concept they were embodying.

There are many seventeenth- and eighteenth-century artworks in which Ripa's *Iconologia* reverberates, even when, as in figure 8, the artist does not follow his descriptions precisely. However, not every personification of this period derives from the *Iconologia*. For example, there

is a special genre in which the subject of a portrait takes on the signs and appearance of a personification. This *personification portrait* should not be confused with mythological portraits, even though one cannot always clearly distinguish between the two.

In the nineteenth century, personification lost its significance due to the rise of realism, and Ripa's lifework fell into obscurity. In 1927, however, the art historian Emile Mâle rediscovered Ripa when he learned that he could explain many personifications in the visual arts with the help of the *Iconologia*.

In the nineteenth and twentieth centuries, we rarely see embodiments of abstract concepts in paintings. One mainly finds them in sculpture, especially in monuments and the decoration of buildings. They also appear on coins and medals, as well as in political caricature. The best-known example of a modern personification is the Statue of Liberty in New York Harbor.

Literature for Further Study — Personification

For literature on this subject, see also the bibliography to chapter 1 (p. 21) and the bibliography to chapter 3 (p. 43).

1. L. Deubner, *"Personifikationen abstrakter Begriffe."* In *Ausführliches Lexikon der Griechischen und Römischen Mythologie,* ed. W.H. Roscher. Leipzig 1902–1909, 3: 2: 2068–169.

 In this comprehensive article, Deubner elucidates the origins of personification and how it figures in Greek and Roman art and literature.

2. F. Stössl, *"Personifikationen."* In *Pauly's Real-Encyklopädie der classischen Altertumswissenschaft (Neue Bearbeitung G. Wissowa).* Stuttgart 1937, 37:19:1: 1042–58.

 This article, except for certain additions, is identical in content to the Deubner article mentioned above.

3. J. Seznec, *The Survival of the Pagan Gods.* French edition, London 1940; English translation, New York 1953.

 This book documents how knowledge of the classical gods/personifications survived through the Middle Ages and became popular during the Renaissance. Highly recommended.

AN INTRODUCTION TO ICONOGRAPHY 35

4. L. Lüdicke-Kaute and O. Holl, *"Personifikationen."* In *Lexikon der christlichen Ikonographie*, ed. E. Kirschbaum. Freiburg im Breisgau 1971, 3:394–407.

 A very useful, short article about personification in early Christian and Medieval art. It includes an overview of the different kinds of personification.

5. E. Mandowsky, *"Untersuchungen zur Iconologie des Cesare Ripa."* Dissertation. Hamburg 1934.

 The first extensive study of Ripa's *Iconologia,* this dissertation deals with Ripa's visual and literary sources, his intellectual ties, and the philosophical background of his work. It also contains a list of selected personifications from Ripa's work, with examples of their application in the visual arts.

6. G. Werner, *Ripas Iconologia. Quellen, Methode, Ziele.* Utrecht 1977.

 Werner discusses Ripa's sources and the illustrations in the various editions of the *Iconologia.*

7. E. Mâle, *L'art religieux du 17ième siècle et du 18ième siècle.* Paris 1951[2], 383–428. Mâle reports his discovery of Ripa's influence and gives some examples of the use of the *Iconologia* in Italian and French art.

8. H. van de Waal, *ICONCLASS: An Iconographic Classification System.* Amsterdam 1979.

 For a listing of literature about personifications in the visual arts, see *Bibliography* 5/6, 7–78.

9. In recent years a series of photomechanical reprints have appeared:

 a. Cesare Ripa, *Iconologia.* New York 1976.
 Reprint of the 1611 Padua edition.
 b. Cesare Ripa, *Iconologia.* Hildesheim 1970.
 Reprint of the 1603 Italian edition, edited by E. Mandowsky.
 c. Cesare Ripa, *Iconologia of Uytbeeldinghe des Verstands.* Soest 1971.
 Reprint of the Dutch edition (Amsterdam 1644). The English introduction by J. Becker is mainly interesting due to his explanation of the influence of Aristotelian philosophy on Ripa.
 d. V. Cartari, *Imagini delli Dei de gl'Antichi.* Instrumentaria Artium I. Graz 1963.
 Reprint of the 1647 Venice edition of Cartari's mythographic handbook, with an introduction by W. Koschatzky.
 e. N. Comes (Conti), *Mythologie, ou explication des fables.* 2 volumes.

New York 1976.
Reprint of the French translation, by J. Baudouin, of Conti's *Mythologiae* (Paris 1627).

10. Y.[D.] [Frossati-] Okayama, *The Ripa Index: Personifications and their Attributes in Five Editions of the Iconologia.* [Doornspijk 1992].

Y.D. Frossati-Okayama of the Department of Art History, Leiden, has compiled a comprehensive index to five different editions of Ripa's *Iconologia* (two Italian, two Dutch, and one French) that enormously simplifies the identification of personifications in the visual arts. The Index consists of two parts. The first part contains a list, with page references for the different editions, of all personifications, their attributes, and their external characteristics, in addition to references for accompanying illustrations. The second part contains a comprehensive alphabetical index in which the personifications' primary attributes and external characteristics are associated with their other traits. This information enormously simplifies the identification of personifications.

11. H. Miedema, *Beeldespraeck. Register op D.P. Pers' uitgave van Cesare Ripa's "Iconologia" (1644).* [Doornspijk 1987].

An alphabetical index to the 1644 Dutch Ripa edition.

Notes

[1] Venice 1556.
[2] Venice 1551.
[3] Translated from the Dutch Ripa edition by D.P. Pers (Amsterdam 1644), 589–90.

3. ALLEGORY

Personifications by themselves rarely take part in any action or activity. They simply stand or sit, and they usually have certain objects and/or animals and plants in their hands or vicinity. More important than this unconnected existence of personifications and, at the same time, one of their reasons for existence is their role in the larger context of the allegory.

We can in general define an allegory in the visual arts as the representation of a personification with one or more other personifications. The central personification might also be portrayed with one or more persons or figures. All of them might be involved in some action.

From this formulation it follows that the depiction of just one personification, without other important figures, cannot be an allegory. Such a representation is either a standard personification (i.e., in which this is the only important figure) or it is a symbolic representation; in this latter case, one or more symbols play the decisive role (see chapter 4). In certain situations, however, we cannot make a clear differentiation.

We can divide allegories into two main groups. The first is the "pure allegory," a combination of personifications that normally partake in some action or activity. These pure allegories often represent a kind of "abstract event," which means that they illustrate an abstract concept or idea in which an action is already embodied. Common examples include *Time Revealing Truth* (figure 9) and *Peace and Justice Kissing* (figure 10).

The allegory of a city or country (figure 11) is a special kind of pure allegory in which personifications do not take part in any action. The illustration usually consists of the personification of the city or country itself surrounded by personifications of abstract concepts that both relate to it and are extolling or glorifying it. Common examples include its military might, the efflorescence of its art life, and its brisk commercial activity.

We find pure allegories particularly in Italian prints of the first half of the seventeenth century. The personifications often hold a nobleman's

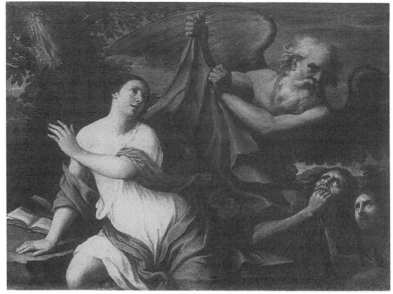

9 Time Revealing Truth. Compare this personification of Truth with that in figure 7. Painting by Giovanni Domenico Cerrini.

personal coat of arms and glorify him.

Another important form of pure allegory is the so-called "triumph." It usually presents a carriage in which a triumphant personification is enthroned; other personifications usually surround the carriage (figures 12 and 21). Roman consuls and emperors used triumphal carriages for their processions, but in the art of the Middle Ages we hardly ever encounter them. Their popularity rose during the Renaissance, principally because of Francesco Petrarch's mid-fourteenth century book, *I Trionfi*. Many editions of this work were illustrated with triumphal carriages, although Petrarch only mentions a carriage in his "Triumph of Love." Besides displaying representations of abstract concepts, triumphal carriages can also present an historical personality as the triumphant figure.

The presence of historical personages brings us to the second important form of allegory, which we will call "non-pure allegory." In them we find one or more personifications as main characters surrounded by other persons and figures who are not really personifica-

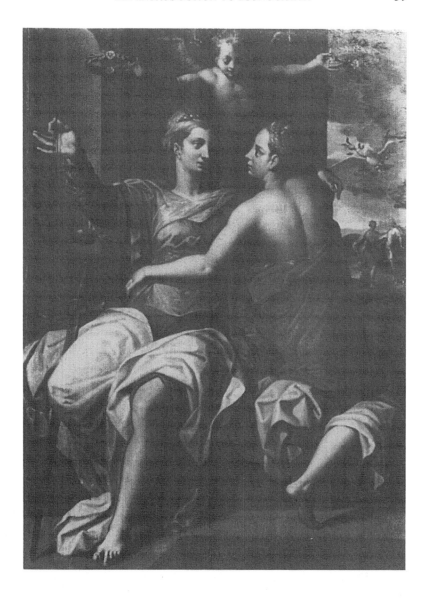

10 Peace and Justice Kissing. The subject stems from Psalm 85:11. Painting by Otto van Veen (Vaenius).

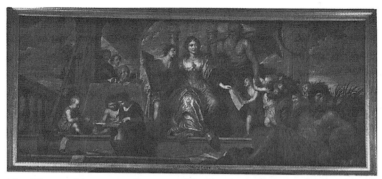

11 Allegory of Antwerp as Patroness of the Fine Arts. Painting and Father Time flank the personification of the city, while in the foreground is the personification of the river Schelde with a cornucopia. Painting by Theodoor Boeyermans.

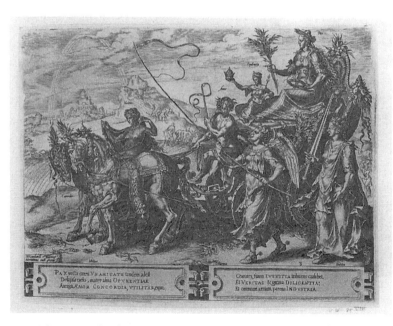

12 The Triumph of Peace. Peace is accompanied by Love, Truth, Justice, and Diligence, among others. Copper engraving by Hiëronymus Cock after Maerten van Heemskerck.

AN INTRODUCTION TO ICONOGRAPHY 41

tions. These secondary characters can range from historical personalities to saints and persons from the Bible. However, they may oftentimes be construed as personifications as well; Moses, for instance, can personify the Old Testament.

An important group of non-pure allegories portray a person or family. In these representations an historical personality, such as a scholar or count, is surrounded by personifications who glorify his work, allude to aspects of the period during which he reigned, or refer to certain features of his character. There also exist a few other forms of allegory, such as allegories of historical events, which are quite unusual and can therefore be disregarded.

We must mention that allegories often contain gods and other figures of classical mythology, but that we should view these persons as personifications. In many allegories, Minerva (Pallas Athena) is the personification of Wisdom and should not be identified as a goddess. Occasionally, allegories consist entirely of "mythological personifications." For these reasons there are sometimes doubts about a picture being an allegory or simply depicting a story from classical mythology.

In some churches and palaces there are whole series of images and/or sculptures in which personifications and other figures are somehow connected with one another. Even when not displayed together, individual works of this kind may belong to an allegorical *Gesamtkunstwerk*, or allegorical program. Usually at the foundation of such a program is a text, frequently written by a scholar, that explains the meanings of each character and its relationships with the others. Only a few texts that inspired such programs have been preserved, and some meanings of these allegorical programs, especially ceiling frescoes, still elude art historians attempting to decipher them.

The history of allegory logically proceeds on a parallel course to that of the personification, since the one is based on the other. From literary sources we know that the Greeks recognized allegory as a means of expression, for *allegory* comes from the Greek *allegorein*, which means "to say differently" as well as "to speak in images." Some significant examples of allegorical representations have also come to us from Roman antiquity. The Middle Ages used allegory primarily in the illumination of books, almost always concentrating on a few dogmatic Christian themes, such as the "Battle Between the Virtues and the Vices." In

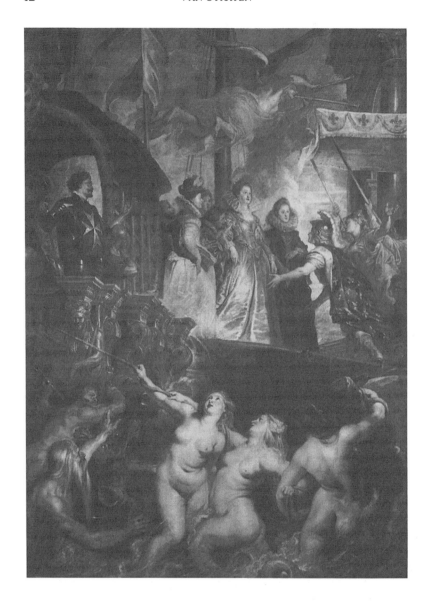

13 The Arrival of Maria de'Medici in Marseilles. She is welcomed by the personification of France, while Fama (Fame) hovers in the air. Painting by Peter Paul Rubens.

An Introduction to Iconography 43

the late Middle Ages and the Renaissance, however, allegory occurred much more frequently, especially in Italy, where it reached its zenith in the important humanist centers of Florence and Venice. From there it spread quickly to western Europe, probably first to France where, in the palace of Fontainebleau between 1541 and 1545, Rosso Fiorentino and Primaticcio decorated rooms in which allegory plays an important role. Prints containing allegories of historical personalities appeared at the beginning of the sixteenth century in Holland and France. This type of allegory remained popular in the art of the baroque, as we have already mentioned. Rubens' cycle on Maria de' Medici represents what is probably its most spectacular example (figure 13).

The influence of Ripa's *Iconologia* was, as chapter 2 demonstrates, very extensive in the seventeenth and most of the eighteenth centuries. That influence remains visible in the decoration of churches and palaces, as well as in many individual works of art. Artists and scholars used the *Iconologia* (although certainly not slavishly) to create a huge variety of allegories and allegorical programs. In the eighteenth century, allegory lost much of its spirit and originality, but its final collapse began at the beginning of the nineteenth century. Influenced by realism, artists and critics harbored strong doubts about the usefulness of allegory and personification as means of expression for the visual arts. Worthy of mention, however, is the curious attempt of J.J. Winckelmann to rescue personification and allegory through the publication of a kind of modern *Iconologia*, the *Versuch einer Allegorie besonders für die Kunst* (Dresden 1766). Since the beginning of the nineteenth century, allegorical representations have become increasingly scarce, confined almost entirely to sculptural decorations of public buildings.

Literature for Further Study — Allegory

For literature on this subject, see also the bibliography to chapter 1 (p. 21) and the bibliography to chapter 2 (p. 34).

1. J. Held, "Allegorie." In *Reallexikon zur deutschen Kunstgeschichte*. Stuttgart 1937, 1: 346-65.

 Even though quite dated, this still continues to be the best general article on allegory in the visual arts.

44 VAN STRATEN

2. L. Kaute, "Allegorie." In *Lexikon der christlichen Ikonographie*, ed. E. Kirschbaum.

Freiburg im Breisgau 1968, 1: 97-100.
A short overview of allegory in Christian art.

3. R. Hinks, *Myth and Allegory in Ancient Art*. Studies of the Warburg Institute 4. London 1939.

A very good book about allegory and personification in Greek and Roman art.

4. L.D. Couprie, "De allegorie in de negentiende-eeuwse realistische kunst." In *Opstellen voor H. van de Waal*. Leidse kunsthistorische reeks 3, with English summary. Leiden 1970, 28-44.

In this essay, Couprie deals with the slow decline of allegory in the nineteenth century. A more recent book about eighteenth-century allegory and personification, among other topics, is H.-T. Wappenschmidt, *Allegorie, Symbol und Historienbild im späten 19. Jahrhundert. Zum Problem von Schein und Sein* (München 1984).

4. SYMBOLS, ATTRIBUTES, AND SYMBOLIC REPRESENTATIONS

There is hardly a more difficult term to define in art history than *symbol*. Some authors interpret it broadly while others, in contrast, explain it narrowly. We will suggest the most useful definition possible: a symbol in the visual arts is an object (in the broadest sense), a plant, an animal, or a sign (number, letter, gesture, etc.) that contains, in a certain context, a deeper meaning.

As Göran Hermerén states in his book *Representation and Meaning in the Visual Arts* (page 78), something must meet three conditions before we can call it a symbol:

1. It makes informed beholders think of whatever it symbolizes, if they contemplate it under standard conditions.

2. Those for which it is a symbol, including the artist, are able to specify what it symbolizes, at least on demand.

3. It does not depict or portray whatever it symbolizes.

To sum up, one must assume that a symbol encourages the spectator to think of something other than what the object represents, e.g.: a plant, an animal, or a sign as such. This assumption implies, of course, that the spectator knows the possible meanings alluded to by the artist; otherwise, the symbol could not be understood. It is often difficult today for spectators to recognize and interpret symbols of earlier centuries. Their values, once common knowledge—at least among the educated— have been forgotten or are familiar only to the few.

Although a symbol can have various meanings, it usually conceals a particular abstract concept. A palette and paint brushes is, for example, a symbol for the art of painting, and a skull—which in the visual arts often indicates the transience of human life—is the typical sign for *memento-mori* and the symbol of Death (figure 14). But often symbols may refer to something more tangible, perhaps even to an incident or a story. In representations of the Crucifixion, for example, a skull at the foot of a cross might refer to the name of the hill on which Christ was cruci-

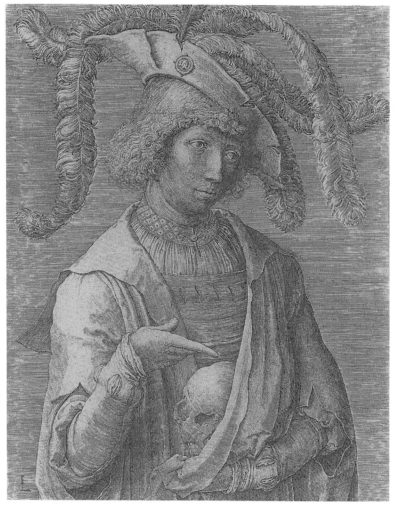

14 "Memento mori": Man with a Skull. Copper-engraving by Lucas van Leyden (compare with figure 21).

fied since "Golgotha" means "skull-place" in Hebrew (figure 15). But this death's head might also refer to the Legend of the True Cross, the story of the Cross on which Christ died. In this story, a branch from the Tree of Knowledge of Good and Evil was planted on Adam's grave, which was located precisely where Christ was later crucified; the Cross

An Introduction to Iconography

15 The Crucifixion of Christ (Matthew 27:34-58; Mark 15:23-45; Luke 23:33-52; John 19:18-38). Painting (occasionally attributed to Hans Holbein the Elder).

was cut from the tree that had grown from the branch on Adam's grave. The deeper meaning of this story is that Christ liberated mankind from the sin that Adam and Eve brought into the world.

Another group of symbols stand for particular people or figures. Jupiter, for example, is occasionally depicted as an eagle, and a fish can symbolize Christ, especially in early Christian art.

Christians developed an ingenious system of symbolism that rapidly expanded during the Middle Ages. Modern art historians have come

48 VAN STRATEN

to believe that they associated symbolic meanings with many of the objects, plants, animals, and signs that appear in artworks. Such profuse references are present as well in the profane sphere of genre painting and even occasionally in mythological representations.

Although symbols abound in the visual arts of almost every epoch, it is not always easy to discover or analyze their connotations. They can vary in their meanings, as we can see in the example of the death's head. This multiplicity becomes even clearer when one looks at encyclopaedic works such as Federico Picinelli's *Mundus symbolicus in emblematum universitate*.[1] This book offers an important compilation of symbols and their possible connotations; several comparable works also existed in the Middle Ages. A symbol's meaning, and thus its interpretation, seems to depend on the context as well as the time and the place in which it was used. But since we cannot apply this rule of thumb to all cases without reservation, the interpretation of symbols often becomes an object of contention among art historians.

*　　*　　*

We will now turn to a special kind of symbol in the visual arts: the attribute. As we have seen in chapter 2, personifications are usually accompanied by certain objects, plants, and animals that then become part of the personification. We call these "requisites" *attributes*, or symbols that are closely connected in a certain way with a person or personification. As this definition makes clear, attributes may belong not only to personifications but also to saints, mythological and biblical figures, and even historical personalities.

Attributes serve a double purpose: they enable spectators to identify a person or personification and they convey something about the figure itself by referring to a biographical episode, to his or her station or rank, to a certain trait of character, or to certain qualities. Saints, for example, are often accompanied by one or more attributes from their martyrdoms; we can thereby learn about their lives (figures 16 and 17). An example of an attribute that clarifies a character trait is the lily, which in most representations of the Annunciation refers to Mary's purity and virginity (figure 18). Attributes of personifications refer primarily to qualities of character as a matter of course, since personifications gen-

An Introduction to Iconography 49

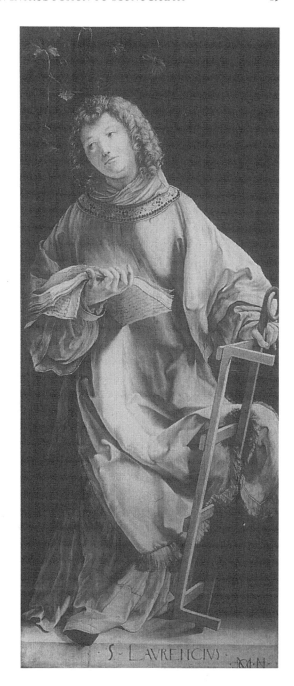

16 Saint Lawrence with his most important attribute, the gridiron on which he was burned; his life story is recounted in the *Golden Legend*. Painting by Matthias Grünewald.

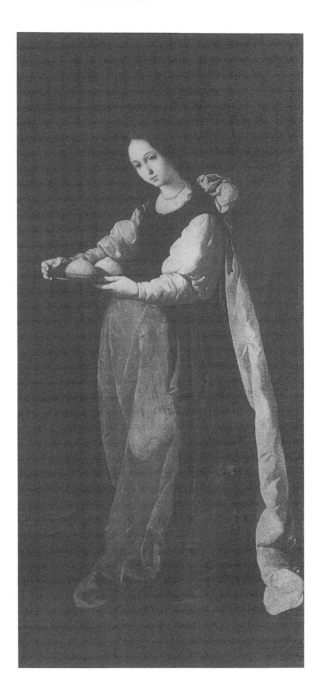

17 Saint Agatha. On a plate she carries her breasts, cut off during her martyrdom. Her life story is recounted in the *Golden Legend*. Painting by Francesco Zurbaran.

An Introduction to Iconography

erally have no life stories.

The goddess Venus, who has little Cupid as her most important attribute, is one of the few exceptions to the rule that attributes must be objects, animals, or plants. Another example is the archangel Raphael, who has the young Tobias as his attribute.

Attributes can be divided into individual attributes, which belong to a particular person or personification, and general attributes, which pertain to a group of persons. The second category is concerned primarily with attributes belonging to a profession or a function (broadly defined). Thus a king in the visual arts almost always wears a crown, and a saint normally has a halo. Such general attributes do not always convey a figure's exact identity in a work of art, since members of the group have the same attribute: nearly every saint has a halo, and every king a crown. Nevertheless, general attributes can help identify a figure, since they limit the number of possibilities and direct our attention in a certain direction, to a specific profession or a function. Clothes can also play an important role in identifying figures.

In order to make an identity absolutely unambiguous, the artist can supply one or more individual attributes. Many figures in the visual arts have more than one, and the combination of attributes itself usually yields a positive identification. The importance of the combination applies particularly to personifications, for they often possess both general and individual attributes. Moreover, many figures have traditional but unique outward appearances, further simplifying their identification.

The addition of attributes is a very old method of distinguishing figures. While the Egyptian and Greek gods possessed attributes that alluded to aspects of their personalities, the legendary Greek heroes usually had attributes that referred to their heroic deeds. One of Hercules' attributes, for example, is the hide of the Nemean lion he killed. In classical Roman art the attributes of the gods and goddesses seldom recall their characters or qualities; instead, they refer to their functions or to the cults associated with them.

In early Christian art, almost no attributes pertain to individuals. Only a few general attributes remain from classical art, such as the halo and the scroll. Individuals' attributes appear sporadically from the fifth century on, but normally persons and figures are identified by the accompanying text or by appearing in well-known, recognizable scenes.

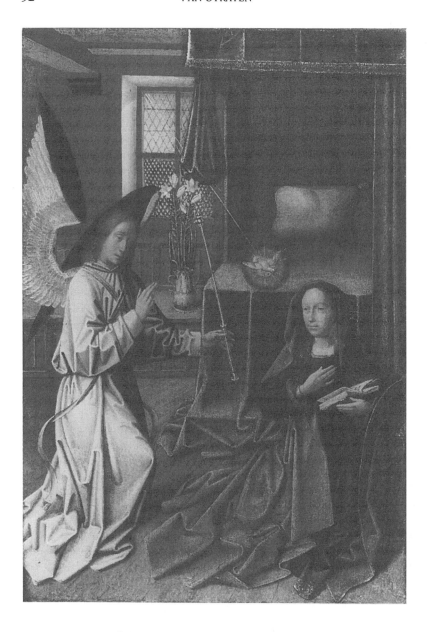

18 Annunciation of Christ's Birth (Luke 1:26-38). Center panel of a triptych. Dutch (?) master, ca. 1490.

AN INTRODUCTION TO ICONOGRAPHY 53

Toward the end of the twelfth century, changing conditions and demands for more identifiable figures in places such as sculptural decorations on church portals made attributes more important. Saints were furnished with the necessary objects, plants, or animals, and later the classical gods and personifications regained the outward appearances described by mythographic literature. From the late Middle Ages onward, persons and figures in the visual arts are practically always portrayed with their attributes.

* * *

Although we have defined *symbol* and *attribute*, we have yet to discuss *symbolic representation*. Perhaps it is best to explain the concept by saying that a *symbolic representation* is a non-allegorical and non-narrative representation in which one or more symbols play the leading role.

Many art historians refer to the concept of symbolic representation for every work that they believe has a deeper meaning, including allegories and even narrative representations (pictures that render a certain story or narrative, inspired by literary sources). In our scheme, personifications, not symbols, play the most important role in allegories. And in the case of narrative representations, the account or story itself might have a deeper meaning. Moreover, it is not always clear in these narrative representations whether a deeper meaning is present or not. For example, in the *Portrait of a Young Woman as Lucretia* (figure 19), there are no symbols that suggest the artist is alluding to the abstract concept of Virtue. We can however know from literary sources that narrative representations may contain such abstract meanings. We should therefore refrain from calling allegories and narrative representations "symbolic images" even when it is difficult, especially in some cases, to make a clear distinction between the several categories.

Many still lifes with deeper meanings, such as the "Vanitas" still lifes that refer to the transience of our existence, present good examples of clear symbolic images (figure 20). Representations such as the copper engraving *Man with a Skull* by Lucas van Leyden (figure 14) may also be called symbolic images.

In still lifes and portraits (figure 21), symbols are often quite expressive and convey obvious symbolic meaning. In other cases, symbols

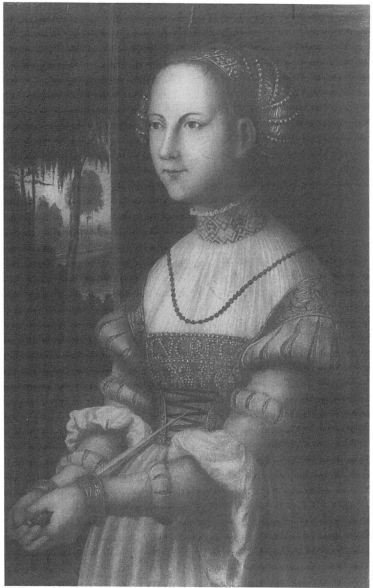

19 Portrait of a Young Woman as Lucretia. The connection between the Lucretia theme and the term virtue is made clear in this painting (compare figure 47). The material comes from Ovid's *Fasti* 2, 725-852, and from Livy's *Ab urbe condita* 1, 57-59, among others. Painting by the monogrammist AB.

An Introduction to Iconography

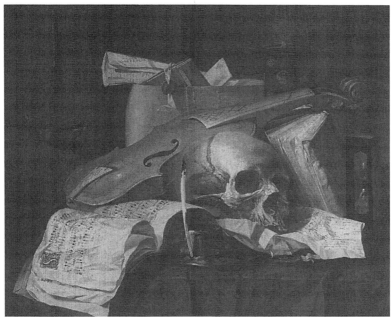

20 "Vanitas" still life with skull, hourglass, violin with broken strings, etc. Painting by N. L. Peschier.

are less clear. For example, genre paintings (which are often classified as symbolic representations) tend to impart deeper meanings through objects, animals, and plants that are parts of everyday life and seem to appear as a matter of course (figure 22). Appearing to lack special significance, the symbols do not always provide clear "warnings" that there is more in the picture than is evident. C. Brown provides a general overview of Dutch genre paintings of the seventeenth century in *Scenes of Everyday Life: Dutch Genre Paintings of the Seventeenth Century*.[2] The exhibition catalogue *Masters of Seventeenth-Century Dutch Genre Painting* is also a good introduction to the field.[3]

Because of its importance for iconographic research, one other particular group of symbolic representations — emblems — will be treated more extensively, especially in regard to Dutch genre art of the seventeenth century.

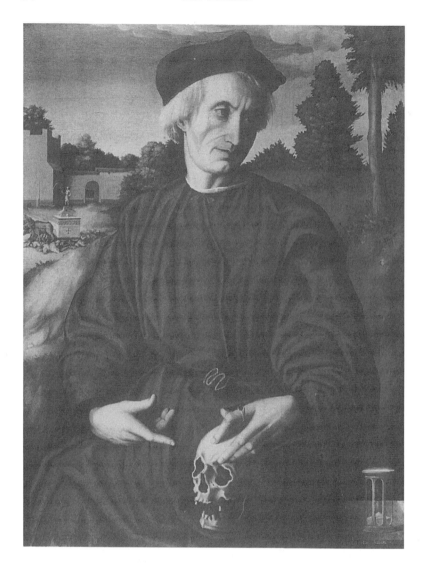

21 Portrait of a Cleric with a Skull (Pope Hadrian VI?). In the background is a triumph of Death, and beside the man is an hourglass. Painting by Francesco Ubertini.

An Introduction to Iconography

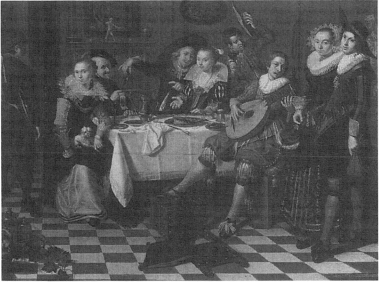

22 Genre painting: *A Cheerful Social Gathering as Representation of the Five Senses*; at right, the portrait of a married couple. Painting by Isack Elyas.

Emblems and Their Origin

Emblems (figure 23) almost always incorporate three fundamental elements: the motto (*lemma*), the image (*pictura, icon*), and the text (*epigram*). The motto and the text are often in Latin. Because of the combination of text and image, the emblem is a half-literary, half-pictorial form of art. The emblem's three elements usually impart a certain abstract, moral-didactic idea, or a more general thought or "maxim." Ideally, each element contributes to the emblem's primary meaning, but in practice the text often solves and explains the "problem" or riddle conveyed by the motto and image.

Originally the emblem's basic element was the epigram; the picture merely served as an elucidating illustration. Ancient Greek epigrams—short poems concentrating on a single thought—were entirely familiar to the Italian humanists of the early sixteenth century. In part, emblems are a revival of the classical poetic form of epigrams.

EMBLEMATA.
XIX.

Des menfches leven is een ſtrijd,
Die noyt als met den menſch' en ſlijt.

Een weddingh, en geſtrijd : twee trecken even zeere,
Aen eē gedraeyde korſt, zoo hart, als broos en teere.
Een beeld, een wonder-beeld, van 't menſchelick ghe-
　ſlacht,　　　　　　　　　　　　　　　　(kracht.
Verkeert, verſteent, vervleeſcht, heel zonder geeſt, of
Hier ſtaen de bodē Gods, daer ſtaen des duyvels knechtē:
De menſche ſtaet in 't mid, daerom ſy ſtadigh vechten.
Zoo werden wy geſleurt, getrocken, en gereckt;
Tot dat wy eynd'lick zijn met duyſter aerd' bedeckt.

23　Emblem from Johan de Brune's *Emblemata of Zinne-werck*

Around the middle of the sixteenth century, the emblem's three-part arrangement had just started to become popular when the image or *pictura* grew into the important element of the emblem. It then became the function of the text to reveal and explain the deeper meaning of the picture and motto. In some cases, authors even include separate texts to offer different explanations of the same *pictura*.

How did emblems actually come into being? In addition to the influence of Greek epigrams, there are two other factors that inspired the art of emblems: *hieroglyphs* and *devices*. Hieroglyphs — probably the most important element from which emblems arose — are literally "holy signs" (in this context, signs that the ancient Egyptians used as script). They were somewhat familiar to Europeans during the fifteenth and sixteenth centuries. In Rome there were, for example, Egyptian obelisks with hieroglyphic inscriptions. But a more important contribution to the dissemination of hieroglyphs was the purchase by a Florentine priest, Christophorus de' Buondelmonti, of an unusual manuscript on the island of Andros. This manuscript was written in Greek by a certain Horapollo (or Horus Apollo) Niliacus, who supposedly lived in Alexandria during the fourth century, and was thought to contain explanations of Egyptian hieroglyphs. After buying the manuscript in 1419, Buondelmonti brought it to Florence, where humanist scholars studied and translated it. The Greek text appeared in print in 1505, and the first Latin edition was published in 1517. Translations into other languages were later published as well.

In the fifteenth and sixteenth centuries, it was believed that the ancient Greeks, including Horapollo (who was assumed to have lived much earlier than the fourth century), knew the "secrets" of hieroglyphs. People also supposed that Greek philosophy, such as Plato's, derived from the knowledge and wisdom of ancient Egyptian priests. Scholars maintained that by decoding hieroglyphs they could discover the source of all wisdom. By the seventeenth century, people were justly questioning the authenticity of Horapollo's text, but by then hieroglyphs had already exerted a great deal of influence over the literature of emblems.

Here is an example of a text by Horapollo:

> When they (the Egyptians) wish to depict a king fleeing from a fool, they draw an elephant with a pig. For the elephant, when he hears a pig squeal, flees. (G. Boas, no. 66, page 104)

60 VAN STRATEN

Hieroglyphs were never used frequently in art, except as illustrations to Horapollo's text and in emblems and printer's marks (figure 24).

The other important element in the origin of emblems are *devices*. A device generally combines a motto and a symbol (or a small symbolic representation), which together represent the principle of life or the "slogan" of a certain person or family. Devices evolved during the end of the fourteenth century and into the fifteenth in France. They spread into Italy at the end of the fifteenth century, during the French conquest of parts of northern Italy. The French soldiers and officers wore the personal devices of their noble leaders. As in the case of hieroglyphs, devices were collected and studied by humanist scholars. One scholar, Paolo Giovio, wrote the book *Imprese militari e amorose.*[4]

In addition to Greek epigrams, hieroglyphs, and devices, we should mention a fourth element that contributed to the emergence of emblems: the tradition of metaphorical thinking that originated in the Middle Ages. This tradition, in particular, provided a widespread fondness for all that was allegorical and symbolic. It was this fertile ground from which other elements blossomed and which led eventually to the development of the emblem-genre.

The first and most important emblem book ever published is Andrea Alciatus' *Emblematum Liber*, originally a collection of ninety-eight emblems printed in 1531 by Heinrich Steiner in Augsburg. Aliciatus' little emblem book supposedly came into being more or less by accident. Alciatus (1492-1550), a lawyer from Milan, actually intended to publish an entirely ordinary collection of epigrams, several of which, by the way, were translations of ancient Greek epigrams. The publisher and printer, Steiner, took care, however, that the texts had accompanying illustrations, perhaps in consideration of less educated readers. It is also possible that Alciatus intented to have the epigrams illustrated. In any event, the wood engravings were modeled on drawings by Jörg Breu (figures 25 and 26). The *Emblematum Liber* was a huge success, with more than 150 (often expanded) editions appearing through the middle of the eighteenth century. And, what is still more important, hundreds of authors followed Alciatus' example, first in France and then throughout western Europe. From the sixteenth to the eighteenth centuries, a total of approximately 2,500 emblem books were published, including variant editions. The majority of these books originated in the Nether-

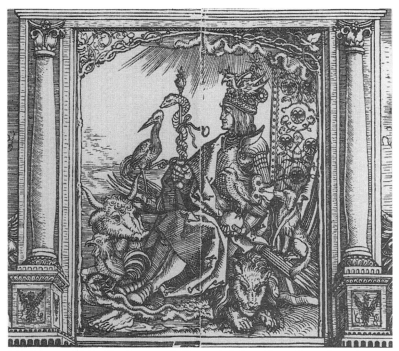

24 Emperor Maximilian I surrounded by symbols from Horapollo, such as a dog with a stole as a symbol for a prince or judge, a lion as a symbol for power and courage, and a globe entwined by a snake as a symbol of the fact that Maximilian reigns over a great deal of the earth. Detail from the Great Arch of Triumph, a woodcut by Albrecht Dürer.

lands (about 750) and in Germany (about 675).

We may differentiate between different kinds of emblems, such as those of a religious or political nature, love emblems (a Dutch specialty), moral-didactic emblems, and many others. Emblem books frequently contain only one specific kind of emblem.

In their themes and subjects, emblems' images or *picturae* encompass enormous variety. Many are purely symbolic representations, but they can also be personifications and even narrative representations taken from the Bible or from classical mythology.

For art historians and iconographers in particular, emblems represent an increasingly significant field of research. The importance of their influence in seventeenth-century art, especially to Dutch genre paint-

25 Two pages from Andrea Alciati's *Emblematum Liber*.

ing, is becoming more and more evident. The study of emblems can reveal the deeper meaning of many genre scenes, as E. de Jongh and his students showed in the famous catalogue to the 1976 exhibition "*Tot lering en vermaak*" ("For Your Knowledge and Entertainment"), mounted at the Rijksmuseum in Amsterdam. Similar to this catalogue is the German guide to the exhibition *Die Sprache der Bilder. Realität und Bedeutung in der niederländischen Malerei des 17. Jahrhunderts.*[5]

The Canadian scholar Peter M. Daly is working on an *Index Emblematicus*, in which he makes all emblem books systematically accessible according to many different viewpoints. The first two volumes, on Alciatus' *Emblematum Liber*, were published in 1985.

In the remainder of this section, we will briefly introduce emblem books by five authors. Although the selection is somewhat arbitrary by necessity, these works, in addition to Alciatus' book, contain the most influential collections of emblems.

An Introduction to Iconography

94 AND. ALC. EMBLEM. LIB.

In fertilitatem sibi ipsi damnosam. XXXIX

Ludibrium pueris lapides iacientibus, hoc me
In triuio posuit rustica cura nucem.
Quæ laceris ramis perstrictoq́; ardua libro,
Certatim fundis per latus omne petor.
Quid sterili posset contingere turpius? eheu,
Infelix fructus in mea damna fero.

26 Emblem from Andrea Alciati's Parisian edition of 1542: A tree is destroyed because of its fruitfulness.

27 Emblem from Jacob Cats' *Emblemata moralia et aeconomica:* A tree entangled and choked by ivy as a symbol for false friendship.

AN INTRODUCTION TO ICONOGRAPHY

65

1. Joachim Camerarius (1534–1598), *Symbolorum et emblematum...*

 Camerarius wrote four important emblem books, each of which has a particular theme and contains a hundred emblems. All four volumes appeared in Nuremberg. The first (1590) focuses on plants; the second (1595), quadrupeds; the third (1596), birds and insects; and the last volume (1604), which appeared posthumously, fishes and reptiles. The pictures of the emblems are generally purely symbolic.

2. Jacob Cats (1577–1660) was one of the most important Dutch writers of the seventeenth century and one of the most popular. His books were read by all segments of the population, and his influence on the visual arts was extensive. Since 1655, his collected works have appeared in many editions under the title *Alle de werken* (*All the Works*). Of his emblematic works, the *Emblemata moralia et aeconomica* and the *Proteus* (*Sinne- en minnebeelden*), both printed in Rotterdam in 1627, are most important (figure 27). The *picturae* of his emblems are occasionally already complete genre scenes in themselves.

3. Gabriel Rollenhagen (1583–ca. 1619). Two important emblem books by him are *Nucleus. Emblematum Selectissimorum...* (Arnhem 1611) and *Selectorum emblematum. Centuria secunda* (Arnhem 1613) (figure 28). Both collections contain a hundred emblems, and the important engraver Crispyn de Passe made the copper engravings. Most of the *picturae* are symbolic representations.

4. Otho Vaenius (Otto van Veen) (1556–1629), *Amorum emblemata* (figure 29). This is the most important little emblem book by Vaenius, who was one of the teachers of Rubens. It contains 124 emblems featuring Cupid, and was printed for the first time in Antwerp in 1608. It is a good example of the typically Netherlandish taste for amorous emblems.

5. Roemer Visscher (1547–1620), *Sinne-poppen* (figure 30). This collection of 180 emblems, which appeared for the first time in 1614 in Amsterdam, is notable for its realistic images. It often portrays commodities, such as a foot warmer, but mainly focuses on activities such as swimming and ice skating.

28 Emblem from Gabriel Rollenhagen: Light is no help to the blind, the owl cannot see by day.

AN INTRODUCTION TO ICONOGRAPHY

Literature for Further Study —
Symbols, Attributes, and Symbolic Representations

For literature on these themes see also the bibliography to chapter 1 (p. 21) and the bibliography to Chapter 2 (p. 34).

1. H. Wentzel, "Attribute." In *Reallexikon zur deutschen Kunstgeschichte*. Stuttgart 1937, 1: 1212-20.
 A good, useful article about attributes.

2. R. Volp & L. Kaute, "Attribute." In *Lexikon der christlichen Ikonographie*, ed. E. Kirschbaum. Freiburg im Breisgau 1968, 1: 197-201.
 This short article relies mainly on Wentzel's work.

3. L. Réau, *Iconographie de l'art Chrétien*. Paris 1955, 1: 416-30.
 Réau deals here with the different categories of saints' attributes.

4. G. Poschat, *Der Symbolbegriff in der Ästhetik und Kunstwissenschaft*. Köln 1983.
 In the first part of this profound study, the author deals with historical changes in the meanings of *symbol* and *symbolism* during the eighteenth and nineteenth centuries. In the second part, he takes issue with twentieth-century philosophical reflections on symbols, including those of Warburg, Freud, Panofsky, Cassirer, and Hermerén, among others.

5. R. Wittkower, "Interpretation of Visual Symbols." In Idem, *Allegory and the Migration of Symbols*, London 1977, 173-87.
 In this selection from *The Collected Essays of Rudolf Wittkower*, Wittkower draws attention to some important problems in the interpretation of symbols.

6. E. Schaper, "The Art Symbol." *British Journal of Aesthetics* 4 (1964), 228-39.
 This article provides an overview of the term *symbol* in the nineteenth and twentieth centuries.

7. G. Berefelt, "On Symbol and Allegory." In *Konsthistoriska studier tillägnade Sten Karling*, Stockholm 1966, 321-40.
 Berefelt discusses the use of different terms in iconography, especially within Romanticism. At the same time he discusses the difference between symbolic representations and allegory.

29 Emblem from Otto van Veen (Vaenius): Love manages to bridle even the obstinate.

8. H. van de Waal, *ICONCLASS, An Iconographic Classification System*. Amsterdam 1973-1983, Bibliography 1: 2/3, 4I, 4II.

Presents literature about specific symbols in the visual arts.

Literature for Further Study — Emblems and Hieroglyphs

An extensive bibliography of literature about emblems appears in A. Henkel & A. Schöne, *Emblemata. Handbuch zur Sinnbildkunst des 16. und 17. Jahrhunderts*, Stuttgart 1976². In the first edition the bibliography appeared as a separate volume.

1. M. Praz, *Studies in Seventeenth-Century Imagery*. 2nd revised edition. Roma 1964. Supplemental volume by M. Praz & H.M.J. Sayles, Roma 1974.

 This work, first published in 1939, is the first important study on emblems. Praz explains the character, function, and meaning of emblems by

30 Emblem from Roemer Visscher: The foot warmer is favored by the ladies and more important to them than men.

placing them within their cultural and historical backgrounds. The work also contains an extensive list of emblem books. For a near complete bibliography of emblem books, see the different publications by J. Landwehr in the series *Bibliotheca Emblematica*.

2. W.S. Hekscher & K.A. Wirth, "Emblem, Emblembuch." In *Reallexikon zur deutschen Kunstgeschichte*. Stuttgart 1959, 5: 85-228.

 This is one of the best and most comprehensive publications in the field of emblematics. Many aspects of emblems and emblem books are treated thoroughly.

3. A. Schöne, *Emblematik und Drama im Zeitalter des Barock*. München 1964.

 Albrecht Schöne, an authority in this field, gives a general introduction to emblematics in the second chapter of this book.

4. K. Porteman, *Inleiding tot de Nederlandse emblemataliteratuur*. Groningen 1977.

 Porteman gives a good introduction to Dutch emblem books and deals especially with the different kinds of emblems. The second chapter is especially interesting because of the critical analysis of Schöne's and Hekscher/Wirth's emblem theories. This little book can be particularly recommended; unfortunately, it is only published in Dutch.

5. E. de Jongh, *Zinne- en minnebeelden in de schilderkunst van de 17de eeuw*. [Amsterdam] 1967.

 De Jongh gives an introduction to emblems and their origins; actually, this little book is the first demonstration of the great influence of emblem literature on seventeenth century Dutch art. Well worth reading are also several other publications by de Jongh in this field.

6. P.M. Daly, *Emblem Theory: Recent German Contributions to the Characterization of the Emblem Genre*. Wolfenbütteler Forschungen 9. Nendeln 1979.

 This publication provides a good overview of the German emblem theories, especially those of Albrecht Schöne and Dietrich W. Jöns. Daly is attempting to construct an *Index Emblematicus*, an inventory and index of known emblem books. More about his plans in: P.M. Daly, ed., *The European Emblem: Toward an Index Emblematicus* (Waterloo, Ontario 1980), 29-57; and Idem, "Zur Inventarisierung der Emblematik: ein Arbeitsbericht," *Jahrbuch für internationale Germanistik* 15:1 (1983), 100-20. The first two volumes of the *Index Emblematicus* are: P.M. Daly (ed.), *Andreas Alciatus*, 2 volumes, Toronto (1985). They include a discussion of Alciatus' life and various indices on subjects of the *picturae*, mottos, etc.

An Introduction to Iconography

7. F.G.W. Leeman, *Alciatus' emblemata. Denkbeelden en voorbeelden*. Dissertation. Groningen 1984.

 The newest study of Alciatus' *Emblematum Liber*, this book primarily investigates the genesis of the collection and the differences between the 1531 edition and the Paris edition of 1534. The last chapter deals with the emblem theories of the sixteenth century.

8. G. Boas, *The Hieroglyphics of Horapollo*. Bollingen series 23. New York 1950.

 This version of Horapollo is useful for art historians. The translation is supplemented by two indices, one for symbols and a second for symbolized themes.

9. L. Volkmann, *Bilderschriften der Renaissance: Hieroglyphik und Emblematik in ihren Beziehungen und Fortwirkungen*. Reprint of the Leipzig edition of 1923. Nieuwkoop 1962.

 A very good summary of the central article on hieroglyphs and emblems by K. Giehlow, "Die Hieroglyphenkunde des Humanismus in der Allegorie der Renaissance," *Jahrbuch der kunsthistorischen Sammlungen des allerhöchsten Kaiserhauses* 32 (1915), 1-218.

10. H. Biedermann, *Dictionary of Symbolism*. New York 1992.

 Translation of *Knaurs Lexikon der Symbole* (Munich 1989). This volume contains many illustrations and brief articles concerning the symbols associated with various names and objects. A pictorial index of illustration and an index of terms is included.

11. *The Herder Symbol Dictionary: Symbols from Art, Archaeology, Mythology, Literature and Religion*. Wilmette, Illinois 1986.

 Originally published as *Herder Lexikon: Symbole* (Freiburg 1978). The volume contains many small illustrations.

Notes

[1] Cologne 1687; original Italian edition, Milan 1653.
[2] London 1984.
[3] Philadelphia Museum of Art 1984.
[4] Rome 1555.
[5] Herzog-Anton-Ulrich-Museum, Braunschweig 1978.

PRACTICAL SECTION

5. LITERARY SOURCES OF SUBJECTS IN ART

We can divide sources of themes in the visual arts into two main groups: the "real" world and literature in the broadest sense. Our "real" environment supplies the subjects, or "motifs," for representations of landscapes, seascapes, portraits, still lifes, and genre scenes. We have discussed some literary sources for these categories — emblems, for instance — in the preceding chapters.

We are concerned in this chapter with literature that supplies the themes and subjects for narrative representations in art; that is, for artworks in which a scene from a story or history is the main theme. When such an artwork is a painting, we sometimes call it a "history painting." We should not confuse this rather vague term with an "historical representation," or representation of an event from post-classical history. On this distinction, we must mention an important exhibition catalogue on 17th-century Dutch history painting, *God, Saints & Heroes.*[1]

Narrative representations that are based on literary sources may be divided into three groups: religious themes; subjects deriving from classical mythology and ancient history; and themes connected to non-religious, post-classical literature. Narrative representations form an especially interesting area for the curious iconographer, since in them the visual arts and literature approach one another very closely. It stands to reason that the iconographer who investigates a representation that refers to a literary theme must concentrate intensively on potential sources in literature. For most stories transformed into artistic images, several sources usually exist that differ only in their details. These small differences occasionally enable the iconographer to isolate a specific edition as the artist's literary source.

In the following sections we will mention only the most commonly used literary sources—works frequently used by artists as sources of inspiration. We will discuss iconographic handbooks of themes and subjects in art in the next chapter.

75

31 A printed page from the *Biblia Pauperum*. In the middle, Christ's Temptation (Matthew 4:3; Luke 4:3) as anti-type. Right and left, scenes from the Old Testament: Esau selling his birthright for a dish of lentils (Genesis 25:29-34) and the Temptation of Eve and Adam by the snake (Genesis 3:1-7).

Sources of Religious Subjects

It should surprise nobody that the most important source for religious themes in the visual arts is the Bible. As everyone knows, the Bible includes the Old and New Testaments. The Old Testament relates the story of the people of Israel from the beginning of the world until shortly before the birth of Christ. The New Testament recounts the birth, life, and death of Christ, as well as the lives and acts of His disciples, the apostles.

The most ancient part of the Old Testament was written in Hebrew more than a thousand years before the birth of Christ. By 250 B.C., most of the Old Testament books had been translated into Greek. With the addition of other books, collected as the Apocrypha, the Old Testament was complete around 100 B.C., and the Greek edition, or *Septuagint*, was available to the early Christians. Shortly afterwards it was also translated into Latin. Saint Jerome, who lived from around 340 to 420 A.D., made the most important Latin translation of the Old and New Testaments; this version, the *Vulgate*, was popular during the Middle Ages and is still used today by the Roman Catholic Church. During the Reformation, the only Old Testament books that Protestants recognized belonged to the Hebrew edition. While included in the *Septuagint* and the *Vulgate*, the newer books, or Apocrypha, are not part of the Protestant Bible.

The New Testament was probably written during the second half of the first and the first half of the second centuries A.D. It was officially adopted in its present form during the Synod of Rome in 382; St. Augustine established the definitive sequence of the books around 397.

Until the late Middle Ages, the most important artistic form for depicting biblical themes and subjects was the illumination of manuscripts. In the thirteenth century, some variants of the Bible appeared in which the illuminations were not simply illustrations of the text but had their own significance. The images themselves became more important than the text and possessed deeper meanings; consequently, their references to the text almost entirely disappeared. The most important and influential example of this genre is the *Biblia Pauperum* (*Poor Man's Bible*), which depicts the life of Christ in typological form. That is, it

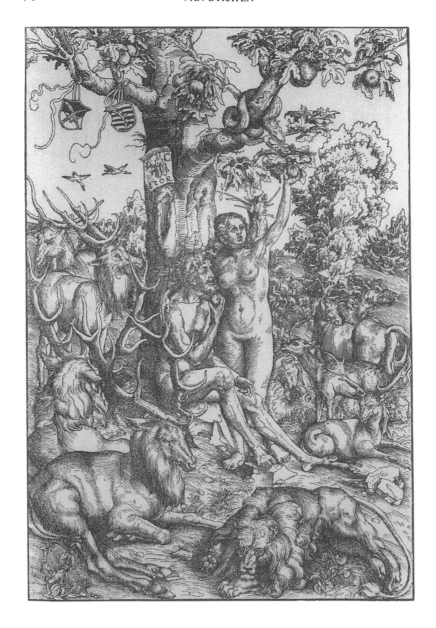

32 Adam and Eve. Woodcut by Lucas Cranach the Elder.

An Introduction to Iconography 79

compares Old Testament scenes with corresponding episodes from the New Testament, the former thus functioning as prefigurations (types) of the latter (anti-types). Here are two examples of such comparisons:

> In a way similar to Abraham, who climbed up the mountain with firewood in order to sacrifice Isaac (= type), Christ climbed the mountain, Golgotha, with the wood of the Cross in order to be crucified (= anti-type).

> and

> In a way similar to Eve, who was tempted in Paradise by the devil in the form of a snake (= type), Christ was led into temptation by the devil in the wilderness (= anti-type). (figure 31)

This format established many connections between the Old and New Testaments. As a rule, there are two or three types for every anti-type.

The *Biblia Pauperum*, published in the first half of the thirteenth century, frequently served as a source for monumental works of art, such as stained glass church windows. Two other important typological works, both originating around the middle of the fourteenth century, are the *Speculum Humanae Salvationis* and the *Concordantia Caritatis*.

As for Old Testament representations, in addition to the Bible another important source is the *Jewish Antiquities* by Flavius Josephus. Written ca. 80-94 A.D., this book renders large parts of the Old Testament in a historicizing manner and was especially popular in the seventeenth century. It also contains a number of variants of traditional biblical stories and several legends that do not appear in the Bible.

As a source for representations of scenes from the life of Christ, we should mention the *Meditationes Vitae Christi* (*Meditations on the Life of Christ*). It probably appeared during the second half of the thirteenth century in Tuscany, and artists occasionally used it during the late Middle Ages. The author is unknown but must have been a Franciscan monk.

There is no doubt that the most important sourcebook for religious subjects besides the Bible is the *Legenda Aurea* (*Golden Legend*), written by Jacobus de Voragine, Bishop of Genoa, around 1265. The *Legenda Aurea* compiles a large number of stories based on the New Testament and, more importantly, contains 155 "vitae" or biographies of saints.

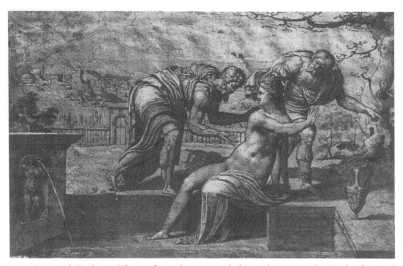

33 Susannah Bathing. Theme from the apocryphal Supplement to the Book of Daniel 13:32. Drawing by Lambert Ryckx.

Composed in the era's easily comprehensible Latin, the legends lack complicated theological explanations and commentaries. Clearly products of popular culture, the legends are folktales with certain scholarly pretensions, such as etymological explanations of saints' names. The saints' lives served as important sources for artists' works (compare figures 16, 17, 38, and 39). Soon after it was written, the book appeared in several languages. Even though the representation of saints was officially restricted after the Council of Trent in 1563 and the Church forbade the *Legenda Aurea*, its influence persisted well into the seventeenth century.

The first pictorial representations of biblical themes appear in Jewish art, despite Judaism's forbiddance of such pictures. The most famous examples are no doubt the frescoes of the Dura-Europos Synagogue (now in the Museum of Damascus), created between the years 245 and 256. Early Christians, especially in Italy, obviously borrowed certain elements of the Jewish pictorial tradition for decorating sarcophagi and catacombs. The illuminations of early Christian book-scrolls and codices probably reflect the influence of Jewish examples as well.

By far the greatest number of representations in the visual arts dur-

An Introduction to Iconography

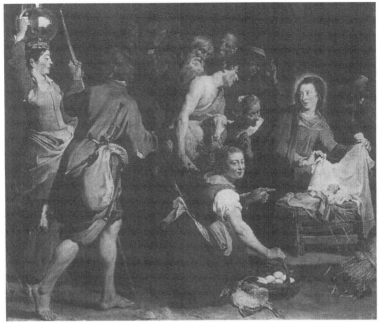

34 The Adoration of the Shepherds (Luke 2:16-17). Painting by Jan Cossiers.

ing the Middle Ages treat religious themes, and from the end of the thirteenth century onward there is a strong narrative tendency in renditions of stories. Many later medieval images are not simply religious representations, but are instead complicated programs with symbolic meanings usually based on theological dogmas. During the Renaissance and Baroque periods many of these symbolic meanings disappeared or were replaced by others. Until well into the nineteenth century, religious subjects dominated Western narrative art. Only then did they lose their importance; now they appear only rarely in "great" art.

There is great variety among representations from the Old Testament, and no particular scenes clearly predominate. Perhaps only the story of Adam and Eve occurs more frequently than other Old Testament narratives (figures 31 and 32). In the Apocrypha, artists have drawn inspiration most often from the Book of Tobit, the Book of Judith (see figure 55), and the appendix to the Book of Daniel with the story

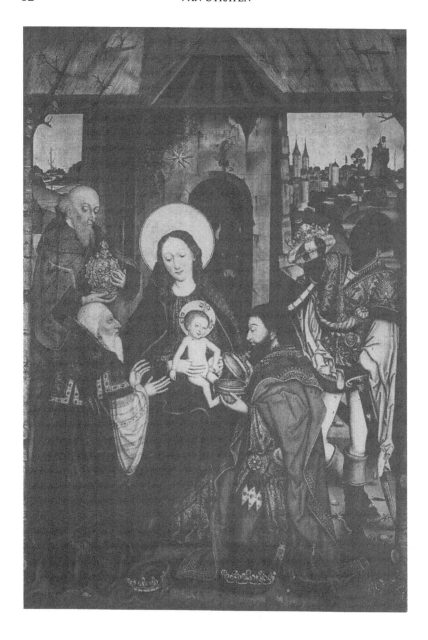

35 The Adoration of the Magi (Matthew 2:11). Part of an altarpiece by Jörg Stöcker.

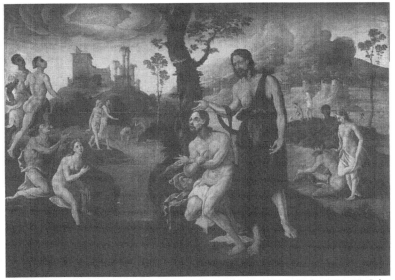

36 The Baptism of Christ (Matthew 3:13-17; Mark 1:9-11; Luke 3:21-22; John 1:29-34). Painting from the School of Jan van Scorel.

of Susannah in her bath (figure 33).

Among New Testament scenes, almost all episodes from the life of Christ have often been depicted. The most popular stories include the Annunciation of the Birth of Christ to Mary (figure 18), the Adoration of the Shepherds (figure 34), and the Adoration of the Magi (figure 35), the Baptism of Christ in the Jordan by John the Baptist (figure 36), the Flagellation of Christ (figure 53), and the Crucifixion of Christ on Golgotha (figures 15 and 37). Scenes from the stories of the apostles and the Revelation of Saint John appear only occasionally and almost exclusively in book-illuminations and prints.

Among the most frequently rendered saints in the visual arts are St. Jerome (figure 38), St. Anthony (the Abbot) (figure 39), St. Catherine of Alexandria, and Mary Magdelene (figure 40).

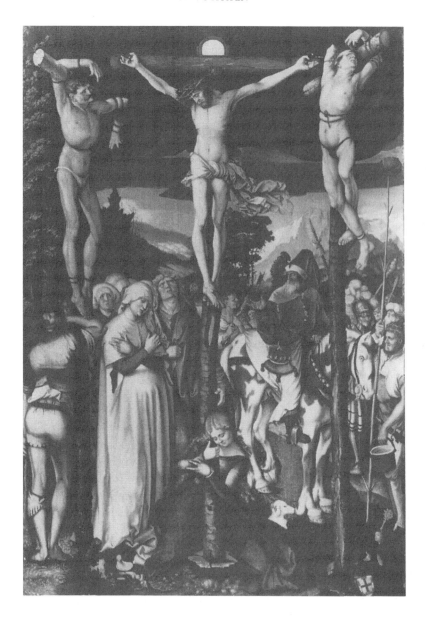

37 The Crucifixion of Christ (Matthew 27:34-58; Mark 15:23-45; Luke 23:33-52; John 19:18-38). Painting by Hans Baldung Grien.

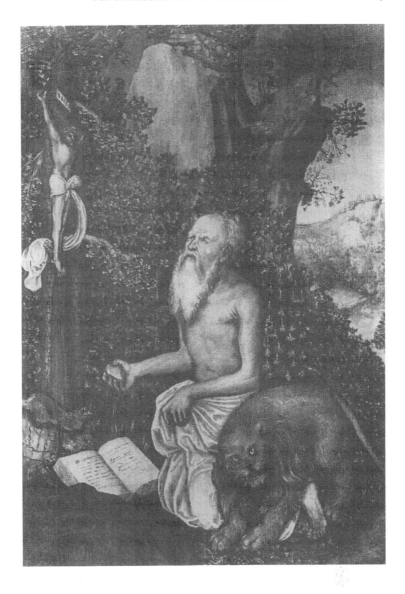

38 The penitent St. Jerome with his most important attribute, the lion. The story of the saint is recounted in the *Golden Legend.* Painting by Lucas Cranach the Elder.

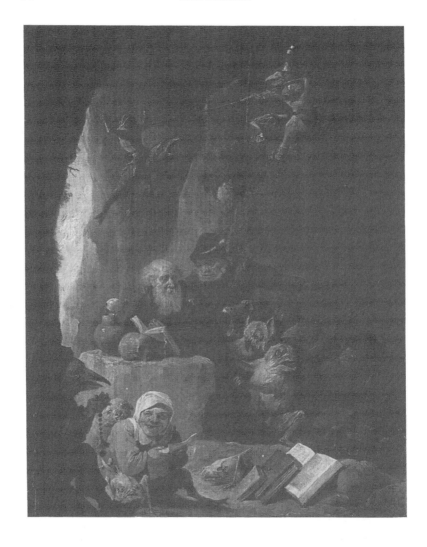

39 The Temptation of St. Anthony. His life is recounted in the *Golden Legend*.
Painting by David Teniers II.

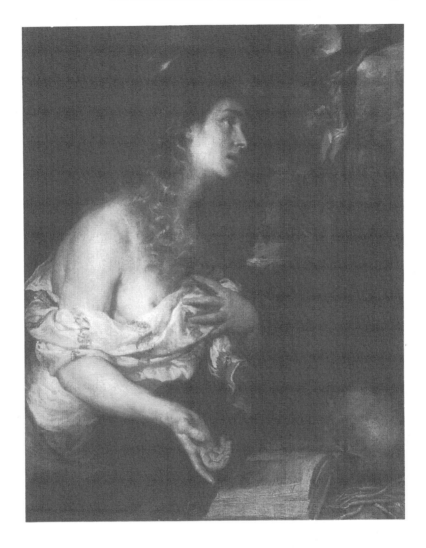

40 The penitent Mary Magdalene. Painting by Mateo Cerezo.

Sources of Classical Subjects

For representations from the field of classical mythology, Ovid's *Metamorphoses* is unquestionably the most important source. Possibly half of all artworks concerned with mythological themes are based on this collection of approximately 250 stories. Ovid the poet was born Publius Ovidius Naso in 43 B.C. in the vicinity of Rome and died in exile in 17 or 18 A.D. Ovid tells his tales in a loosely chronological order with a unique style that is never boring. He begins with the Genesis of the World, then describes the Four Ages of the World (the Golden, Silver, Bronze and Iron) and after many stories finally arrives at what was for him contemporary history—the murder of Ceasar. The leitmotiv in Ovid's narrative is the metamorphosis or transformation of persons, animals, and objects into other shapes (figures 43-45). Many of his stories are adaptations of episodes from Homer and works by other Greeks.

The *Metamorphoses* was relatively unknown until well into the twelfth century, when it became popular. Artists frequently used it as a source of inspiration during the sixteenth and seventeenth centuries. Ovid's work has even been called the "Painter's Bible." In Dutch art, Karel van Mander's "Wtlegginghe op den Metamorphosis" ("Explanations of the *Metamorphoses*"), published in his *Schilderboeck (Painter's Book)*,[2] has been influential because van Mander offers an ethical-moral interpretation of Ovid's stories. A variation on the *Metamorphoses* is the *Ovide Moralisée*, an anonymous, early fourteenth-century work in which the Ovidian stories are interpreted as Christian parables.

Other works by Ovid used as sources include the *Fasti (Festivals)*, a collection of legends, historical events, and descriptions of rites and festivals (figure 19); and the *Heroides*, a compilation of fictitious letters by famous mythological and historical women to their lovers or husbands.

No other work of classical literature has ever been as popular a source as the *Metamorphoses*. Nevertheless, we should mention several other books that artists have often used for themes. Foremost among these are the *Iliad* and the *Odyssey* by Homer. The *Iliad* describes the siege and fall of Troy, as well as the deeds of the heroes Achilles, Patroclus, Hector, and many others. The *Odyssey* is an account of the adventures of Ulysses on his return journey from Troy to Ithaca, where his faithful spouse Penelope, beset by a horde of suitors, is waiting for him. The

An Introduction to Iconography

Iliad and the *Odyssey* seem to have been written around 700 B.C. somewhere in Ionia. Both are compilations of stories that until that point had survived only through the oral tradition. Renderings of Homer's stories are, however, relatively rare in the visual arts (figure 41).

Perhaps more important than the *Iliad* and the *Odyssey* is Virgil's *Aeneid*. The poet Publius Vergilius Maro lived from 70 to 19 B.C., mainly in Rome. The last ten years of his life were spent in Naples, where he wrote the *Aeneid* — the story of the travels and adventures of Aeneas, who, after the fall of Troy, searched for a new fatherland with several of his fellow citizens and finally landed in Italy. Episodes from the *Aeneid*, such as Aeneas' flight from the burning Troy (figure 42), his love affair with Dido, and his descent into the underworld, are frequently depicted in the visual arts.

We can briefly mention four other classical works in connection with artists' literary sources:

1. Plutarch, *Parallel Lives*. Plutarch (ca. 46—120 A.D.) describes the lives of fifty famous Greeks and Romans. He compares the life of a Greek to that of a Roman twenty-three times and investigates correspondences and differences. Many of the anecdotes and historical events he recounts occur in the visual arts, but other authors have also described these scenes.

2. Gaius Julius Hyginus, *Fabulae* (*Fables*). Despite still being called the *Fabulae* of Hyginus, this collection of some 300 short mythological stories is now thought to have been written in the second century A.D. This dating means that Hyginus cannot have written it, since he must have lived in the second half of first century A.D. Many stories from the *Fabulae* are adaptations of other authors' works, but often with considerable deviations (see figure 46).

3. Valerius Maximus, *De factis dictisque memorabilibus libri IX* (*Memorable Facts and Sayings in Nine Volumes*). Valerius Maximus, who lived in the first half of the first century, collected hundreds of stories and anecdotes that provide examples of good and bad behavior as moral exempla. His book was popular primarily in the Middle Ages and Renaissance.

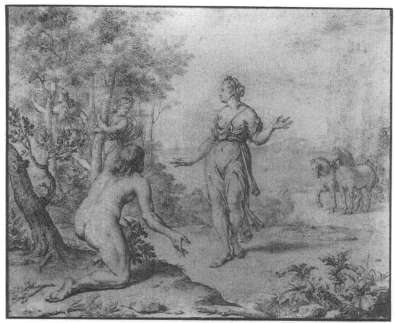

41 The Encounter of Odysseus and Nausicaa on the Beach, a theme from Homer's *Odyssey* (book 6). Drawing by Willem van Mieris.

4. Titus Livius, *Ab urbe condita* (*The History of Rome*). In this work, Livy (59 B.C.–17 A.D.) describes the history of Rome in 142 books; unfortunately, only 35 have been handed down. Particularly during the Renaissance and Baroque ages, several episodes enjoyed great popularity in the visual arts (see figure 19).

We naturally find the earliest representations of Greek and Roman mythological themes in classical art itself (e.g., in vase painting and frescoes). Between the late Roman period and the early Renaissance, classical subjects in the arts were limited almost entirely to book-illuminations, as in the *Ovide Moralisée*. Interest in classical antiquities increased considerably during the Renaissance because of archaeological excavations and the publication of mythographic handbooks, among other factors (see chapter 2). Perhaps the fact that mythological themes also offered the possibility of representing nude figures and "unchaste" or voluptuous scenes played a role as well.

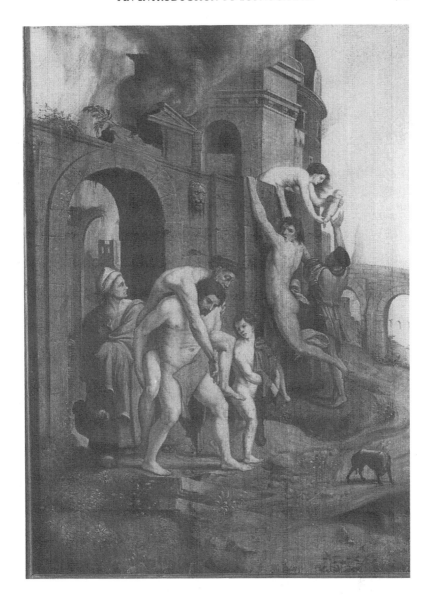

42 Aeneas and his Family Flee from the Burning Troy (*Aeneid* 2:617-729). Painting from the vicinity of Jan van Scorel, after Raphael.

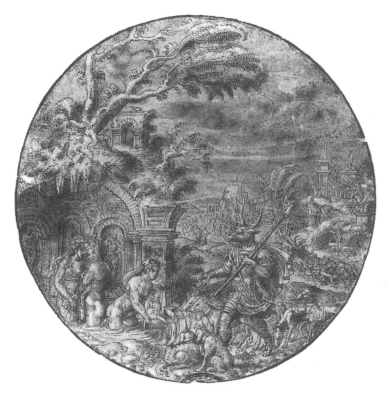

43 The Metamorphosis of Actaeon. Because he has seen her naked while bathing, Diana transforms Actaeon into a stag, whereupon he is torn to pieces by his own hunting dogs. Subject from Ovid's *Metamorphoses* (3:155-252). Drawing by an unknown Dutch artist.

From Italy, the cradle of the classical revival, interest in ancient classical literature (particularly Ovid's *Metamorphoses*) spread rapidly to the rest of western Europe, reaching the height of its popularity in the visual arts during the second half of the sixteenth and the first half of the seventeenth centuries. During the second half of the seventeenth century, the number and variety of representations of classical themes slowly began to ebb.

Among the stories most frequently appropriated from classical literature and ancient history are those of Diana and Actaeon (figure 43),

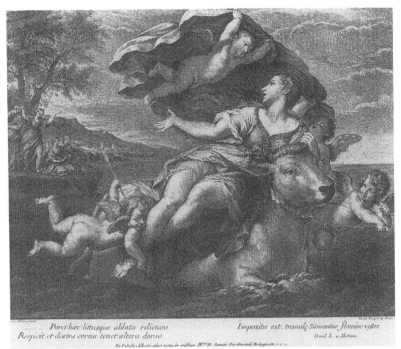

44 The Rape of Europa by Jupiter Disguised as a White Bull. Subject from Ovid's *Metamorphoses* (2:836-875). Copper engraving by Jacob Frey the Elder after Francesco Albani.

the Rape of Europa (figure 44), Venus and Adonis (figure 45), the Judgment of Paris (figure 46) and the Suicide of Lucretia (figures 19 and 47).

Sources of Profane Subjects from Post-Classical Literature

While the number of literary works that inspired visual art is untold, non-religious subjects from post-classical literature have played a comparatively subordinate role in "great" art; only in the nineteenth century did a predilection for them develop. We will mention only a few of the most influential works:

1. Arthurian legend: The various legends about King Arthur and the knights of the Round Table.

45 Venus and Adonis. Subject from Ovid's *Metamorphoses* (10:532-559). Drawing by Anthony van Blockland.

An Introduction to Iconography

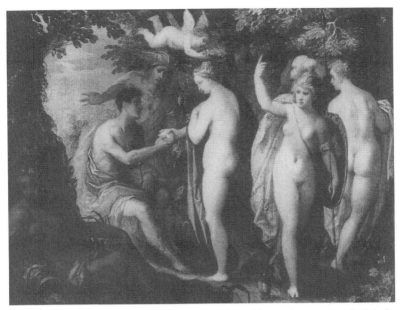

46 The Judgment of Paris. Paris giving Venus the golden apple, an event which indirectly causes the Trojan war. The subject stems from the *Fabulae* by Hyginus and from other authors' works. Painting by Johann Rottenhammer.

2. Dante Alighieri, *Divina Commedia* (*The Divine Comedy*). Completed around 1320, Dante tells the story of his journey with Virgil through Hell (*Inferno*), Purgatory (*Purgatorio*), and Heaven (*Paradiso*).

3. Ludovico Ariosto, *Orlando Furioso* (*The Raging Roland*). Written in 1516 and expanded in 1532, this story about the battles between the Saracens and Christians in the time of Charlemagne features Orlando, Angelica, and Medoro as main characters.

4. Torquato Tasso, *Gerusalemme Liberata* (*Jerusalem Delivered*). This 1575 story about the occupation of Jerusalem by Godfrey of Bouillon during the first crusade is intertwined with love stories, such as Rinaldo and Armida's (figure 48).

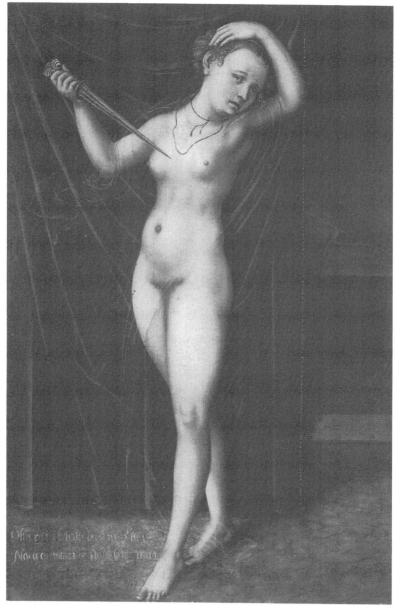

47 The Suicide of Lucretia. Compare with figure 19. Painting by Lucas Cranach the Elder.

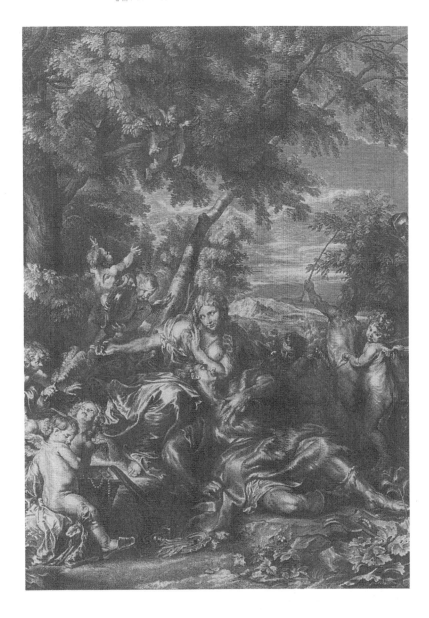

48 Rinaldo and Armida in the Magic Garden. Subject from Tasso's *Gerusalemme Liberata* (14:66). Copper engraving by Pieter de Jode II after Anthony van Dyck.

5. Battista Guarini, *Il Pastor Fido* (*The Faithful Shepherd*). With the final version of 1602, this most important pastoral drama features Silvio, Dorinda, and others as main characters.

Literature for Further Study — Literary Sources

Most of the literary works mentioned in this chapter are available as reprints or in modern translations, often in English.

1. *Dictionary of the Bible.* 2nd revised edition. Edinburgh 1963.

 A comprehensive reference work about the Bible and its different editions (for example, *Septuaginta* and *Vulgata*). Comparable to the German *Bibel-Lexikon*, 2nd revised edition, (Einsiedeln 1968).

2. For literature about specific biblical themes in the visual arts and about the *Biblia Pauperum, Speculum Humanae Salvationis,* and *Concordantia Caritatis*, see H. van de Waal, *ICONCLASS: An Iconographic Classification System* (Amsterdam 1982), *Bibliography 7.*

3. For medieval Christian literature and how it appears in the German visual arts, see also H. Appuhn, *Einführung in die Ikonographie der mittelalterlichen Kunst in Deutschland,* (Darmstadt 1979).

4. For literature about specific themes from post-classical, non-religious literature and classical mythology and history, see H. van de Waal, *ICONCLASS: An Iconographic Classification System* (Amsterdam 1980), *Bibliography 8/9.*

5. For a thorough discussion of mythological representations in Dutch painting, see E.J. Sluijter, *De "Heydensche Fabulen" in de Noordnederlandse schilderkunst, circa 1590-1670,* Dissertation (Leiden 1986).

6. D.C. Allen, *Mysteriously Meant: The Rediscovery of Pagan Symbolism and Allegorical Interpretation in the Renaissance.* Baltimore 1970.

 In this very important study, Allen treats the deeper meanings found within works of classical literature which Renaissance scholars "discovered" in Homer's *Iliad* and *Odyssey*, in Virgil's *Aeneid*, and in the *Metamorphoses* of Ovid, among other works.

7. J.C. Seigneuret (ed.), *Dictionary of Literary Themes and Motifs*. 2 volumes. New York 1988.

These volumes discuss literary depictions of various concepts, actions, and circumstances.

Notes

[1] National Gallery of Art, Washington 1980.
[2] Haarlem 1604.

6. ICONOGRAPHIC HANDBOOKS AND PHOTO ARCHIVES

We will now turn our attention to introducing a number of important iconographic handbooks and iconographically-arranged or accessible photo archives.

Our discussion of handbooks features short descriptions of each book's contents—a supplement researchers will find useful. Since we let the practice of iconographic research guide our selection of handbooks, several books are not iconographic in the strict sense of the word. However, each provides material important to subject analysis and to iconographers, and each is a standard that every art historian should know.

Iconographic Handbooks

In the next chapter we will discuss ICONCLASS, scholars' most important aid for researching iconography. Not a traditional handbook but instead a new method that assembles iconographically interesting material on specific themes and subjects in art, ICONCLASS should be consulted at the beginning of every iconographic investigation. Its bibliography contains references to practically every theme, person, symbol, and other referent in the visual arts. It also includes more general categories, such as literature about allegory, emblems, portraits, landscapes, and the like. The ICONCLASS bibliography refers to several of the works below as general references, discussing them from interesting points of view.

To obtain new literature that does not yet appear in the ICONCLASS bibliography, use the relevant issues of *R.I.L.A.* (*Répertoire International de la Littérature de l'Art* (*International Repertory of the Literature of Art)*[1] or the *Répertoire d'art et d'archéologie.*[2] Both periodicals, which joined forces in 1991, are now published together as *B.H.A.* (*Bibliography of the History of Art)*[3] and offer a subject index for iconography that is, unfortunately, imperfect.

102 VAN STRATEN

Art historians all too often forget the rich sources of information available in dictionaries. Comprehensive dictionaries in almost every modern language can help art historians find meanings of objects or activities that have been forgotten; there are often literary contexts and connotations from the past. For the German language, we can recommend the *Deutsches Wörterbuch von Jacob und Wilhelm Grimm*, Munich 1984.[4] The Dutch *Woordenboek der Nederlandsche Taal (W.N.T.)* is also important, as is the English *Oxford English Dictionary*.

Another major non-iconographical work that covers artists, their lives, and their works is *Allgemeines Lexikon der bildenden Künstler bis zur Gegenwart*, edited by U. Thieme and F. Becker.[5] A new and much expanded edition is now being published as *Allgemeines Künstler-Lexikon (A.K.L.)*.[6] We could mention many other handbooks, such as the *Reallexikon zur deutschen Kunstgeschichte*, but most are too specialized or not sufficiently iconographically relevant. E. Arntzen and R. Rainwater have published a truly comprehensive list of iconographic handbooks in their *Guide to the Literature of Art History*.[7]

Finally, we should briefly mention four libraries that are especially important for iconographers. First is the Zentralinstitut für Kunstgeschichte (Z.I.) (Central Institute for Art History) in Munich, which specializes in religious themes and makes many of its books and periodicals accessible by subject. The library's bibliographic files are available on microfiche. Second, the Warburg Institute in London specializes in subjects from classical mythology and history. Finally, large collections of emblem books are housed in the Art Historical Institute of the University of Utrecht, The Netherlands, and the Herzog-August Library in Wolfenbüttel, Germany.

A. General Reference Works

1. J. Hall, *Dictionary of Subjects and Symbols in Art*. Revised edition. New York 1979.

 This iconographic handbook offers many descriptions of subjects and their customary representations. The author provides references to literary sources for subjects and also associates themes with their common symbols and attributes. The book will primarily interest those who want to familiarize themselves with the most important themes and subjects in art. Unfortunately, it offers no possibilities for further research, since it lacks references

49 A page from Henkel-Schöne's *Emblemata*.

u. Klostermod.: Büstenrelqr, 18. Jh., Kath. v. Giovinazzo (Abb. BiblSS X 42).
G. HARTWAGNER

NIKOLAUS Peregrinus (von Trani) 2. 6., 4. 10. (Transl.)

Quellennachw.: BiblSS IX 949–50. — Griechischer Hirte; durchzog m. e. Kreuz u. d. Ausruf „Kyrie, eleison" S-Ital.; starb i. Alter v. 18 Jahren i. Trani. — Beigesetzt i. d. Kath. ebd.; Patr. v. Trani u. d. Schiffer.

Darst.: Als junger Pilger, Segensgestus: Fresko d. Krypta v. Massafra, 13./14. Jh. (A. Medea, Gli affreschi nelle cripte eremitiche Pugliesi [R 1939] Fig. 134); m. langem Handkreuz: Bronzetür d. Kath. v. Trani (°Boeckler BrTüren Abb. 135); um Hilfe flehende Gläubige m. Kerzen zu Füßen; Altargem., 13./14. Jh., Krypta d. Kath. v. Trani (Lit. 2 Fig. 964). — 20 Szenen seiner Vita a. d. Altargem. v. Trani (ebd. Fig. 965–80).

Lit.: 1. °*Réau* III/2 988; 2. °*Kaftal CS* Nr. 270.
G. HARTWAGNER

NIKOLAUS DE RUPE (DE LA ROCHE) ↗*Nikolaus von Flüe*

NIKOLAUS von Saraisk (NIKOLAJ Sarajskij) ↗*Nikolaus von Myra*

NIKOLAUS Studita Abt, Bek., 4. 2.

Quellennachw.: BHG II 151; °Vies des Saints II 96–7; LThK² VII 998–9; BiblSS IX 952–3. — Sekretär d. hl. ↗Theophilus; i. Bilderstreit m. diesem v. Leon V. eingekerkert; 848 Abt d. Studionklost.; † 868. — Erw. i. °Synaxarium CP 443–4.

Darst.: Die byz. Darst. sind b. Fehlen individuierender Beischriften schwer zu identifizieren; wahrsch. soll d. als Niphon bez. Mönch i. d. Vorlage d. °Strog.Ik. 208–9 am 4. 2. N. Studita darstellen. — Im Westen erst i. d. bar. Erem.stichfolgen.
G. HARTWAGNER

NIKOLAUS TAVELIĆ und GEFÄHRTEN von Jerusalem OFM. Martt., 14.(17.)11. († 1391)

Lit.: (In Jerusalem v. Moslems zerstückelt u. verbrannt; BiblSS XII 148; Kultbestätigung 1889, Kanon. 1970); mehrere Darst. d. 20. Jh. i. Jerusalem (S. Niccolò Tavelić e Compagni [Jer 1970]).

NIKOLAUS von Tolentino OESA, 10. 9.

Quellennachw.: LThK² VII 999; BiblSS IX 953–96. — † um 1245; trat m. 12 Jahren d. OESA bei; bedeutender Prediger u. Wundertäter (über 300 Wunder b. d. Kanon. bestätigt, u.a.: Heilungen, Totenerweckungen u. Schutz vor Unwettern, die auch noch n. seinem Tod b. Anrufung mit i. OESA n. besonderem Ritus geweihten N.-Brötchen erfolgten); † 1305 i. Tolentino. — Beigesetzt i. seiner Kirche zu Tolentino; Kanon. 1446. Im 16./18. Jh. einer d. meistverehrten Hll. Europas u. Amerikas; Patr. u.a. v. Rom, Córdoba, Genua, Venedig, Antwerpen, Lima u. Bayern; der Seelen i. Fegfeuer (Bruderschaft), d. Freiheit, d. Schüler u. d. Lebens.

Darst.: Immer als Augustinereremit i. schwarzer Tracht m. Ledergürtel, überw. jugendlich u. bartlos. Die älteste Darst. v. „Mstr v. Tolentino" i. Tolentino, Bas. S. Nicola, Cappellone, um 1330 (Abb. Lit. 9, 954); sie zeigt d. Rahmen d. späteren Ikonogr.: Lilie, (Regel-)Buch u. Sterne a. Mantel u. um d. Nimbus. Hinzu kommt d. Kruzifix (meist i. d. Rechten): Mittelft. d. lombard. Schule, 15. Jh., Genf, Palazzo Bianco (Abb. ebd. 955); d. Sterne, Andeutung d. Lichterscheinung, die ihm vor seinem Tode b. Gang z. Oratorium vorausging, i. d. Folgezeit reduziert zu e. Stern od. zu e. Art Flammenscheibe m. Engel- od. Christuskopf a. d. Brust: Fresko v. B. Gozzoli, S. Gimi-

1 *Die hll. Augustinus und Monika mit Nikolaus von Tolentino vor der Madonna*, deutscher Holzschnitt des späten 15. Jh., München, Staatliche Graphische Sammlungen

gnano, S. Agostino (Abb. LThK¹ VII 589; Abb. °Ricci 477); öfters auch über d. Haupt schwebend: Tf. v. Giovanni di Paolo, 1456, Montepulciano, S. Agostino (°BollA 4 [1924/25] 541 Fig. 8); od. i. d. Hand getragen: Fresko, 14. Jh., aus S. Elisabetta, Perugia, Pin. Naz. (Lit. 8 Fig. 981). Im geöffneten Buch vielfach Inschr. „praecepta patris mei (Augustini) servavi" o. ä.: Tf. d. lombard. Schule u. Tf. v. Giovanni di Paolo (s. o.). Oft m. Schüssel m. e. Taube bzw. e. Rebhuhn (d. Hl. wies die ihm b. seiner Krankheit gereichten gebratenen Vögel zurück, worauf diese v. Teller aufflogen): Gem. v. Lanfranco, Salamanca (A. E. Pérez Sánchez, Pintura it. del sec. XVII en España [Ma 1956] Tf. 34); Holzschn. d. Hist. Stadtarchivs i. Barcelona (Abb. °Roig 207); genau d. Leg. folgend m. e. fliegenden Vogel u. e. noch a. d. Teller liegenden: Holzschn., spätes 15. Jh., Mü. (Lit. 10 Abb. 1) Ⓐ¹. Mit d. Fieberbroten: Tf.-Gem. i. Rattersdorf (E. Grabner, Die Bilderwand zu Rattersdorf [Eisenstadt 1972] 20–3 Abb. 13). Von Gott gekrönt, m. Teufel zu Füßen: lombard. Tf., Genf (s. o.); Gem. d. Raffael-Schule, 1501, Perugia, Pin. (°Venturi VII/2 Fig. 171); diese Darst. erscheint stets i. d. Missale d. OESA. Ein Unikum d. Darst. m. Kelch u. Hostie sowie Bußgeißel m. d. Fegfeuervision i. bar. Stich v. M. Wenig (E. Grabner, aaO. Abb. 15). Darst. m. Stadtmod.:

50 A page from Kirschbaum's *Lexikon*.

An Introduction to Iconography 105

to iconographic literature. There are several publications comparable to but weaker than the *Dictionary*.

2. A. Pigler, *Barockthemen. Eine Auswahl von Verzeichnissen zur Ikonographie des 17. und 18. Jahrhunderts*. 3 volumes. Budapest 1974[2].

Since Pigler's *Barockthemen* contains iconographically-arranged references to artworks and reproductions from the fifteenth to the nineteenth centuries, its title is a bit misleading. Material is arranged thematically and usually subdivided according to epoch and country. In the first volume are religious themes such as The Old and New Testaments, saints, myths, legends, and the Madonna. The second volume treats profane materials such as Greek and Roman mythology (derived primarily from Ovid's *Metamorphoses*), legends, Greek and Roman history, post-classical history, allegories, genre-scenes, and miscellaneous (which includes "Vanitas" still lifes, for example). An alphabetical index ends the second volume. The third volume is a fairly useless picture atlas. Despite its general value and importance, the work neglects some extremely important themes, such as the Death of the Virgin Mary.

3. A. Henkel & A. Schöne, *Emblemata. Handbuch zur Sinnbildkunst des 16. und 17. Jahrhunderts*. Stuttgart 1976[2]. (see figure 49)

This voluminous work reproduces most of the emblems, with their mottos and texts, from about fifty important and influential emblem books. They are arranged by subject of the *picturae*: plants, animals, mythological scenes, biblical subjects, and others. The texts, usually in Latin, also appear in German translation. A good index of the *picturae* (*Bildregister*) and an equally useful index of the emblems' abstract meanings (*Bedeutungsregister*) make the emblems readily accessible. The bibliography contains an exceptional wealth of information on books and essays on emblematics. While the *Emblemata* is a most valuable handbook for those searching for possible secondary meanings of objects or other symbols in art, one must always remember that Henkel and Schöne treat only about fifty emblem books out of several thousand.

4. E. Frenzel, *Stoffe der Weltliteratur. Ein Lexikon dichtungsgeschichtlicher Längsschnitte*. 7th revised edition. Stuttgart 1988.

Should one want to trace a certain literary figure in art, this book can be a great help. It mentions the literary works in which certain people appear and covers not only modern literature but also the Bible, classical mythology, and classical history. The book is unfortunately incomplete, and a more comprehensive reference work would be quite useful. Comparable to it is the *Dizionario letterario Bompiani, VIII: Personaggi A-Z*, Milano 1950.

106 VAN STRATEN

5. E. Frenzel, *Motive der Weltliteratur. Ein Lexikon dichtungsgeschichtlicher Längsschnitte.* 3rd revised and expanded edition. Stuttgart 1988.

This book introduces motifs of world literature and answers questions such as: "In which literary works does a beggar appear?" While the book lacks a great deal, it is good to know that it exists.

6. M. Lurker, *Dictionary of Gods and Goddesses: Devils and Demons.* London 1987.

Translation of *Lexikon der Gotter and Damonen* (Stuttgart 1984). Brief articles describe the attributes and narrate the stories of a number of mythological and literary personages. A few illustrations are included.

B. Reference Books — Christian Iconography

1. E. Kirschbaum, ed., *Lexikon der christlichen Ikonographie.* 8 volumes. Freiburg im Breisgau 1968-1976. (see figure 50)

This reference work is by far the best on Christian iconography. It treats every theme, symbol, and person down to the last detail, and it provides references, examples from art, and good bibliographical information. The first four volumes examine "general iconography," biblical figures other than saints, and the like. Alphabetical lists of French and English iconographical terms, with references to the German keywords in the *Lexikon,* appear at the end of the fourth volume. The last four volumes discuss practically all the saints in alphabetical order. A useful list of attributes appears at the end of the eighth volume. Iconographers cannot avoid using this dictionary, even though its many abbreviations make it cumbersome.

2. L. Réau, *Iconographie de l'art chrétien.* 3 parts in 6 volumes. Paris 1955-1959.

This is the first extensive, systematically constructed work on Christian iconography. The first part (1 volume), or *"Introduction générale,"* serves primarily as a theoretical introduction to biblical iconography (sources, symbolism, developments), Christian symbols (animals, plants, and the like), and the iconography of saints in general (hagiography, cults). The second part (2 volumes), deals with biblical iconography: one volume covers the Old Testament and the other the New. Réau outlines practically all biblical themes in art in abbreviated form and provides references to Bible texts and works of art as well as a bibliography. Short indices of people's names conclude the pair of volumes. The third part (3 volumes) discusses saints in art. While it has been superseded by the four volumes of Kirschbaum's iconography of saints, it has the advantage of being read-

AN INTRODUCTION TO ICONOGRAPHY

107

able and clearly arranged, since all the scenes that Réau discusses have their own headings. In conclusion, Réau's work continues to be important and useful.

3. G. Schiller, *Ikonographie der christlichen Kunst*. 5 parts in 7 volumes and an index volume. Gütersloh 1966-1991.

R. Schreiner, index volume, Gütersloh 1980.

Despite its title, this work deals almost exclusively with the iconography of Christ and Mary. It is narrower in its interests than comparable works by Kirschbaum and Réau but much more profound. The first three volumes treat representations of Christ in the visual arts: 1. Christ's birth, youth, and miracles; 2. His passion and death; 3. The Resurrection and other themes (e.g., *Majestas Domini* and symbols of Christ). Volume 4.1 covers the Church as an institution, and volume 4.2 is dedicated to the Virgin Mary. The fifth volume, whose first part is text (1990) and second part is plates (1991), concentrates on the Apocalypse of John. Each volume contains a good index and an abundant selection of images. The separate index volume by R. Schreinder comprises, among other things, a list of the non-biblical literary sources mentioned by Schiller. Unfortunately, only the first volume was also published in English (London 1975).

4. *Helps to the Study of the Bible*. 2nd revised edition (with the Apocrypha!) London n.d.

This book features three indices: 1. an index of proper names that occur in the Bible; 2. a subject index; and 3. a concordance of words that appear in the Bible. Should one want to know how and where a certain figure, word, or text occurs in the Bible, this book is very useful. Among comparable works is the *Große Konkordanz zur Luther-Bibel* (Stuttgart 1979). Unfortunately, this book lacks a concordance of the Apocrypha.

5. E. Kautzsch (ed.), *Die Apokryphen und Pseudepigraphen des Alten Testaments*. 2 volumes. Hildesheim 1975[4].

The first volume contains the Apocrypha of the Old Testament. The second includes the pseudepigraphia of the Old Testament, i.e., the non-canonical (or non-biblical) writings attributed to Old Testament prophets but actually composed much later, mostly in the early Christian period. Among these stories are the Martyrdom of Isaiah, the Ascension of Moses, and the Life of Adam and Eve. The second volume also contains an alphabetical index. This set is important because scenes from the pseudepigraphia occur rarely in the visual arts.

VAN STRATEN

309

PLUMES

I. ATTRIBUT DE LA LASCIVETÉ.

Dans une gravure par Aldegrever (Bartsch, VIII, p. 397, n° 110; fig. dans Hollstein, *German*, I, p. 57).

II. « DEVISE » DES MÉDICIS.

Au nombre de trois et considérées comme des plumes d'autruche, ainsi que nous l'avons exposé sous AUTRUCHE (PLUMES D'), elles ont servi de « devise » à Laurent le Magnifique, qui y voyait l'image des trois vertus théologales (Vasari, *Ragionamenti*, p. 13). Les plumes des Médicis entrèrent au Vatican avec les premiers papes de cette famille, Léon X et Clément VII. Elles figurent notamment au plafond de la Salle des Chiarioscuri. Les trois plumes et l'anneau au diamant, autre « devise » des Médicis, furent repris par Laurent de Médicis, 4e duc d'Urbin et neveu de Clément VII (Typotius, *Symbola*, III, Prague, 1603, p. 87-89).

POIDS

I. ATTRIBUT DE L'ARCHITECTURE.

Au revers d'une médaille frappée pour le Bramante, au début du XVIe s., l'Architecture pose le pied droit sur un poids (Hill, 657 et 658, pl. 115).

II. ATTRIBUT DE L'ARITHMÉTIQUE.

Dans une série des sept arts libéraux, par H.S. Beham (Bartsch, VIII, p. 164, n° 124; Hollstein, *German*, III, p. 76 avec fig.).

POIRE

ATTRIBUT DE VÉNUS.

Par confusion avec la * pomme (?).

Dans une plaquette de bronze, travail allemand du XVIe s., à la Nat. Gallery of Art de Washington (*Renaissance Bronzes from the Kress coll.*, 1951, p. 97 avec fig.).

POISSON

I. ATTRIBUT DE LA TEMPÉRANCE.

SOURCE. Religieuse. Allusion aux jours d'abstinence qu'impose l'Eglise et durant lesquels on se nourrit de poisson. Le moyen âge connaissait cet attribut de la Tempérance. On le trouve sur l'étendard qu'elle porte dans une tapisserie allemande du XVe s., actuellement à l'hôtel de ville de Ratisbonne (*Das Rathaus zu Regensburg*, Ratisbonne, 1910, p. 117, fig. p. 107).

ART. Sur l'étendard de la Tempérance dans une gravure par Aldegrever, 1552 (Bartsch, VIII, p. 400, n° 121; fig. dans Hollstein, *German*, I, p. 59).

310

II. LA HAINE.

SOURCE. On lit dans *Isis et Osiris* de Plutarque (chap. 32) : « Les prêtres (égyptiens) ont pour la mer une horreur sacrée... Ils n'ont pas moins d'aversion pour le poisson et le mot « haïr » s'écrit chez eux par un poisson ».

ART. Sur une inscription, qui se trouvait à Saïs dans le temple d'Athéna, un poisson se voyait gravé avec ce sens (Plutarque, ibidem). L'inscription est perdue, mais elle a été reproduite à la Renaissance d'après la description qu'en fait Plutarque (V. sous HIPPOPOTAME; fig. dans Valeriano, XXXI, sous « Humanae vitae conditio » et dans Volkmann, p. 39).

POISSONS (LES)

I. ATTRIBUT DE FÉVRIER dans la représentation allégorique des mois.

SOURCE. Le soleil entre dans ce 12e signe du zodiaque au mois de février.

ART. Dans une gravure du monogrammiste FB, représentant le mois de février, on voit au milieu les Poissons, entourés de nuages (Bartsch, IX, p. 448, n° 26). Les Poissons figurent sur une tapisserie bruxelloise du 2e quart du XVIe s., actuellement au palais Doria à Rome et représentant le mois de février (Göbel, I, 2, n° 145). On trouve ce signe dans la marque de Jean Février ou Febvrier, libraire à Paris de 1571 à 1600 (Renouard, 317-18). Les Poissons dominent février dans des gravures flamandes. Ainsi dans les mois dits « de Hans Bol » (Hollstein, *Dutch*, III, p. 101), dans les mois d'Adrien Collaert (Hollstein, *Dutch*, IV, p. 206 et 207, deux séries). Il en existe une troisième à sujets religieux, non mentionnée par Hollstein, mais dont un exemplaire se trouve au Cabinet des Estampes à Bruxelles).

V. DANSES.

II. ATTRIBUT DE JUPITER, considéré comme planète astrologique.

SOURCE. Les Poissons sont sa « maison de jour », sa « maison de nuit » étant le Sagittaire.

ART. A ce titre les Poissons figurent dans les gravures représentant les « enfants de Jupiter » (Lippmann, A II, B II, C II, D II, E II). On retrouve les Poissons, comme attribut de Jupiter, dans des gravures représentant les sept planètes astrologiques. Ainsi dans la série de H. S. Beham (Bartsch, VIII, p. 162, n° 115; Hollstein, *German*, III, p. 75 avec fig.); dans celle qu'a gravée J. Sadeler d'après M. de Vos (Le Blanc, n° 173; Wurzbach, n° 140; un exemplaire au Cabinet des Estampes à Bruxelles); dans la série du monogrammiste IB (Bartsch, VIII, p. 303, n° 12) et dans celle de certains graveurs anonymes (Bartsch, IX, p. 16, n° 2; p. 46, n° 5). De même au Temple des Malatesta à Rimini (C. Ricci, p. 457, fig. 566) et au plafond de l'Udienza del Cambio à Pérouse (ici fig. 21). Un Amour joue avec deux poissons au bas du caisson consacré à la planète Jupiter au plafond de la salle d'honneur du palais Rucellai à Rome (Saxl, *Antike Götter*, pl. II et texte de Giacomo Zucchi, p. 48).

51 A page from Tervarent's *Attributs et symboles*.

AN INTRODUCTION TO ICONOGRAPHY 109

6. E. Hennecke & W. Schneemelcher, *Neutestamentliche Aprokryphen in deutscher Übersetzung.* 2 volumes. Tübingen 1968-1971.

The *Neutestamentliche Apokryphen* (*New Testament Apocrypha*) contains all the non-canonical (or non-biblical) writings associated with New Testament persons and events. The first volume covers the Gospels and includes the Gospel of Peter and the Gospel of Bartholomew. The second volume includes stories of the apostles and apocalyptic texts, such as the Acts of John and the Apocalypse of Paul. Concluding the second volume is a useful index of persons. Iconographers will consult this work because images from the New Testament's Apocryphal writings appear occasionally in the visual arts. The English version is *The Apocryphal New Testament* by M.R. James (Oxford 1924).

7. *Bibliotheca Sanctorum.* 12 volumes and index. Roma 1961-1970.

This is a very good encyclopedia of saints, although more theological than iconographical. Only the most important saints have their own iconographical rubrics.

8. M. & W. Drake, *Saints and Their Emblems.* London 1916. Reprint, New York 1971.

The first part of this book contains an alphabetical list of saints with their attributes. while the second includes a comprehensive list of attributes, with references to pertinent saints.

9. G. Kaftal, *Iconography of the Saints in Central and South Italian Schools of Painting.* Florence, 1965.

_____ , *Iconography of the Saints in the Painting of North East Italy.* Florence 1978.

_____ , *Iconography of the Saints in the Painting of North West Italy.* Florence 1985.

_____ , *Iconography of the Saints in Tuscan Painting.* Florence 1952.

Under each saint's name, these volumes give the attributes of each saint, and the most complete list of Italian paintings depicting the saints available in any reference book.

10. T. H. Ohlgren, *Illuminated Manuscripts: an Index to Selected Bodleian Library Color Reproductions.* New York 1977; Supplement, 1978.

These two volumes index by subject all of the slides produced by the Bodleian Library of the over 1,800 books and illuminated manuscripts in the Oxford University collection. The manuscripts are indexed by titles, shelfmarks, provenance, dates, languages, artists, authors, and types of manuscripts, as well as by the subject of each illumination.

110 VAN STRATEN

11. T. H. Ohlgren, *Insular and Anglo-Saxon Illuminated Manscripts: An Iconographic Catalogue, c.A.D. 625 to 1100*. New York 1986.

This volume provides an inventory of the illuminations of 229 insular and Anglo-Saxon manuscripts. Indexes are provided to location, authors and titles, places of origin and provenance, dates, and iconographically significant subjects.

12. G. Davidson, *A Dictionary of Angels, Including the Fallen Angels*. New York 1967.

This volume consists of articles on angels by name and type, some of which are illustrated. It also includes an appendix of various tables and lists of types and associated concepts.

13. A.B. Jameson, *The History of Our Lord as Exemplified in Works of Art*. 2 volumes. London 1865.

_____ , *Legends of the Madonna, as Represented in the Fine Arts*. London 1864.

_____ , *Legends of the Monastic Orders as Represented in the Fine Arts*. London 1863.

_____ , *Sacred and Legendary Art as Represented in the Fine Arts*. 2 volumes. London 1863.

Although somewhat dated, these volumes still provide some of the best explanations in English of Christian themes depicted in the fine arts.

C. Reference Books — Profane Iconography

1. R. van Marle, *Iconographie de l'art profane au Moyen-Age et à la Renaissance....* 2 volumes. La Haye 1931-1932.

This is the only comprehensive work on profane, non-narrative subjects in the visual arts of the Middle Ages and Renaissance. The first volume, "La vie quotidienne," treats themes from daily life: nature, relations between the sexes, hunting, war, rural life, and the like. The second volume covers allegories and symbols, with two important sections on Death and Love.

2. G. de Tervarent, *Attributs et symboles dans l'art profane 1450-1600. Dictionnaire d'un langage perdu*. Travaux d'Humanisme et Renaissance 29. Genève 1958.

Supplement and index of proper names. Genève 1964. (see figure 51)

Tervarent has written the best reference work on profane symbols in art between 1450 and 1600. There is an extensive discussion of every symbol

AN INTRODUCTION TO ICONOGRAPHY 111

and/or attribute, including possibilities of meaning, literary sources, and examples from art. In columns 421-430 is an alphabetical list of abstract concepts, mainly personifications.

3. W.H. Roscher (ed.), *Ausführliches Lexikon der Griechischen und Römischen Mythologie*. 10 volumes and supplemental volume. Leipzig 1884-1937.

Although old, this unusually complete dictionary of classical mythology can be helpful when new publications lack information about specific figures. Roscher treats every mythological figure in alphabetical order and for more important persons discusses their means of representation in classical art.

4. F.A. Wright (ed.), *Lemprière's Classical Dictionary of Proper Names Mentioned in Ancient Authors*. Revised edition. London 1949.

Although this book appeared for the first time in 1788 (!), it is still a standard work about the persons and figures who play roles in classical literature. Lemprière not only cites places where these figures appear, but he also gives short, worthwhile biographies. Crowell's *Handbook of Classical Mythology* (New York 1970) is comparable but much less profound.

5. R. Graves, *The Greek Myths*. Revised edition. 2 volumes. Harmondsworth 1960.

Graves systematically summarizes all Greek legends and provides references to classical literary sources. This work can be useful for art historians researching the source of a story or scene in the visual arts and for those who want to refresh their memories about Greek legends.

6. J.D. Beazley, *Attic Black-Figure Vase-Painters*. New York 1978.

 , *Attic Red-Figure Vase-Painters*. 2 volumes. New York 1984.

 , *Paralipomena: Additions to Attic Black-Figure Vase-Painters and to Attic Red-Figure Vase-Painters*. Oxford 1971.

L. Burn, *Beazley Addenda*. Oxford 1982.

T.M. Carpenter, *Beazley Addenda*. Oxford 1989.

These volumes list, in a total of seven volumes, black-figure and red-figure Attic vases in museums, private collections, and the art market. Each item contains information on the subject painted and on bibliographic sources with photographic reproductions of vases. The importance of these volumes within the context of iconography is that an index of mythological subjects is included.

112 VAN STRATEN

7. J.D. Reid, *The Oxford Guide to Classical Mythology in the Arts, 1300-1990.* 2 volumes. New York 1993.

Under the names of mythological personages, these two excellent volumes provide a very thorough listing of works of art, plays, poems, operas, and other representations of classical myths from 1200 to the present. A list of artists is included.

8. M. Rochelle, *Mythological and Classical World Art Index: Locator of Paintings, Sculptures, Frescoes, Manuscript Illuminations, Sketches, Woodcuts, and Engravings Executed 1200 B.C. to 1900 A.C.* Jesserson, N.C. 1991.

Under names of Greek and Roman mythological characters, this small volume lists works of art depicting various narrative scenes involving the character.

9. *Lexicon Iconographicus Mythologiae Classicae [LIMC].* Zurich 1981- (Multivolume work in progress).

This promises to be the most complete listing of works of art depicting Greek and Roman mythological personages. The articles, in French and German, the catalogue of works, and the many illustrations, will make this, when it is completed, the premier source for the iconography of Classical mythology in art.

Photo Archives

With over a million photographs and slides, the Visual Collections Department of Harvard University's Fine Arts Library in Cambridge, Massachusetts is one of the most important art historical photo archives in the United States. The Photo Archive of the Getty Center for the History of Art and the Humanities in Santa Monica, California houses another major visual collection. Because this collection is new and growing, it is still a bit disordered; many areas currently lack good access. The biggest art-historical photo collection in Germany is probably the Zentral-Institut für Kunstgeschichte in Munich. It is arranged, by the way, according to the artist's name. An almost complete photo archive of Dutch art resides at the Rijksbureau voor Kunsthistorische Documentatie (R.K.D.) in the Hague. The Witt Library of the Courtauld Institute in London, with its 1.3 million (!) items, probably has the largest collection of photographs and reproductions of Western European paintings, prints, and drawings. A microfiche copy of the Witt

AN INTRODUCTION TO ICONOGRAPHY 113

Library catalog is commercially available and can be found in several visual collections, including the Getty Center for the History of Art and the Humanities and the Bildarchiv Foto Marburg.

Only a few photo archives are either iconographically arranged or easily consulted for iconographic purposes. We will not mention resources arranged by the ICONCLASS system, since we will take them up in the following chapter.

1. *Index of Christian Art.* Department of Art and Archaelology, Princeton University.

 This exceptionally rich reproduction collection is limited to Christian art from its beginnings to the year 1400. Under main headings like Nature, Scenes, and Figures, and their subdivisions, everything depicted in Christian art from this epoch has a place in the reference system. This collection can be used iconographically, even though it is not iconographically arranged. For this reason, working with the Index is often tiresome. The Bible, the Apocrypha, and the saints' legends obviously play important roles. At the moment, the Index is building a computerized access according to ICONCLASS.

 One of the three copies of this collection is located in the Dumbarton Oaks Library, Washington D.C. There are also copies at the Department of Art History, University of Utrecht, Holland; and at the Istituto Pontificio d'Archeologia, Rome, Italy.

Literature:

H. Woodruff, *The Index of Christian Art at Princeton University.* Princeton 1942.

 A short historical overview and explanation of the Index.

A.C. Esmeijer & W.S. Heckscher, "The Index of Christian Art." *The Indexer* 3 (1963), 97-119.

 A critical review of the Index's advantages and disadvantages.

2. Photographic Collection of the Warburg Institute, London.

 This collection of more than 300,000 reproductions and photographs specializes in subjects from classical mythology and ancient history, but does not neglect other areas. Within the main divisions (e.g., Gods and Myths, Literature, and Religious Iconography), the subjects are arranged alphabetically according to the names of the primary figures. There is just enough systematization in the collection to find one's way, although it may take some time. Computerization is now facilitating searches.

114 VAN STRATEN

3. Koninklijk Instituut voor het Kunstpatrimonium, Brussels.

The collection of photos and reproductions of the art patrimony includes approximately 750,000 pictures of works of art (including architecture) located in Belgium, in both public and private collections. The reproductions are arranged according to the place in Belgium where they are located. The iconographic system is modeled on the arrangement of ICONCLASS but operates without codes. Using this collection can be complicated, but a visit to the art patrimony is well worth the effort.

Literature:

R. van de Walle, "Het fotoarchief van het instituut. Een inventaris van het Belgisch kunstbezit." *Bulletin van het Koninklijk Instituut voor het Kunstpatrimonium* 12 (1970), 86-99.

4. Institut für mittelalterliche Realienkunde Österreichs, Krems/Donau.

This relatively small collection of approximately 15,000 photographs of late Middle Ages arts in Austria includes frescoes, paintings, and book illuminations. An iconographic entry exists in the form of a filing system, but a computer data bank is being set up to facilitate the answering of even detailed questions.

Literature:

Europäische Sachkultur des Mittelalters. Gedenkschriften des zehnjährigen Bestehens des Instituts für mittelalterliche Realienkunde Österreichs, *Sitzungsberichte Österreichische Akademie der Wissenschaften. Philosophisch-Historische Klasse 374.* Veröffentlichungen des Instituts für mittelalterliche Realienkunde Österreichs 4. Wien 1980.

5. Inventory of American Painting, Washington, D.C.

The Inventory, housed in the National Gallery of American Art at the Smithsonian Institution, comprises almost half a million computerized references to mostly American paintings made before 1914. Iconographic access is possible by means of a partly hierarchical keyword-system.

6. Inventaire Général of the Ministère de la Culture, Paris.

The computer at the Inventaire Général provides access to works of art contained in French museums. There are separate databanks for about 25,000 paintings, as well as drawings, sculptures, and other objects. The

data resources of the Inventaire are not usually accessible to the normal user. François Garnier provides iconographical access to works of art with the help of a system of keywords developed and published as *Thesaurus iconographique. Système descriptif des représentations* (Paris 1984).

Notes

[1] Williamstown, Massachusetts 1975 ff.
[2] Paris 1910 ff.
[3] 1991 ff.
[4] 33 volumes; photomechanical reprint of the first edition of 1854.
[5] 37 volumes, Leipzig 1907-1950.
[6] Leipzig 1983 ff.
[7] Part F, London 1980.

7. ICONCLASS: A NEW METHOD OF RESEARCH IN ICONOGRAPHY

The ideal prerequisite for iconographic investigation is documentation that is both broadly designed and systematically arranged by subject. Such documentation should encompass a large number of reproductions or photographs of artworks; at the least, it should contain references to artworks. The documentation should also incorporate the most comprehensive bibliography possible of iconographically interesting literature. Such documentation should greatly simplify an iconographic investigation and would probably make remarkable discoveries possible.

Unfortunately, only some art-historical institutes possess well organized iconographical documentation. Those institutes usually have just a few specialists who can work with the documentation. In addition, print collections and museums tend to classify their holdings according to artists' names and do not have iconographical catalogues of their resources.

For many years the lack of a useful, comprehensive iconographical system was the greatest obstacle to constructing iconographical catalogues. The Dutch scholar Henri van de Waal (University of Leiden), who died in 1972, recognized this impediment and developed a finely meshed iconographical system that encourages the creation of iconographic catalogues of engravings, drawings, paintings, and the like. It also simplifies the indexing of reproductions, bibliographic references, and other materials by subject. This system, ICONCLASS ("an ICONongraphic CLASsification System"), was published between 1972 and 1985; the entire work comprises seventeen volumes. The system's applications, together with its accompanying alphabetical index and comprehensive iconographical bibliography, have proven that ICONCLASS is equal to its tasks. "It works," Professor van de Waal often said. In the present chapter we will demonstrate how the system is constructed and the ways it can be used for iconographical research.

ICONCLASS is essentially an "empty" framework of system numbers (codes or notations) that refer to subjects and objects in the visual arts. Everything that could appear in a work of art, such as themes, plots,

117

73 D 3 Christ's arrest, trial, and torture

73 D 34 2	Judas is disemboweled after a fall	
34 3	Judas hanging himself	
34 4	Judas' punishment in hell	⊕
34 5	chief priests buying the potter's field	
73 D 35	tortures of Christ	⊕
73 D 35 1	flagellation by soldiers, Christ usually tied to a column (Mt. 27:26; Mk. 15:15; Jo. 19:1)	⊕
35 11	preparations for the flagellation	
35 12	Christ with wounds caused by scourging	⊕
35 12 1	Christ on the whipping-post (after the flagellation)	⊕
35 13	Christ collecting his clothes	⊕
73 D 35 2	the crowning with thorns: soldiers with sticks place a thorny crown on Christ's head (Mt. 27:27–31; Mk. 15:16–20; Jo. 19:2–3)	⊕
35 21	preparations for the crowning	
35 22	head of Christ with crown of thorns	
73 D 35 3	mockings of Christ, who may be blindfolded	⊕
35 31	in Caiaphas' palace he is mocked by Jews (Mt. 26:67–68; Mk. 14:65)	
35 32	in Pilate's palace he is mocked by soldiers (Lk. 22:63–65)	
73 D 35 4	Christ resting after his tortures, 'Herrgottsruhbild' 'Christus im Elend' 73 D 52	⊕
73 D 35 5	Christ in prison (alone)	⊕
73 D 36	Pilate showing Christ to the people, 'Ostentatio Christi', 'Ecce Homo' (Jo. 19:4–6) choice between Christ and Barabbas 73 D 32 31 1	⊕
36 1	Christ alone (also called 'Ecce Homo') Man of Sorrows 73 D 73	
73 D 37	Christ, lying on or dragged across a flight of steps, is maltreated in Pilate's presence (breaking of the reed) Scala Santa 11 D 43 5	

for KEY to division 7 see p. 267

52 A page from the ICONCLASS System, volume 7; compare with figure 56 for the pertinent bibliography.

AN INTRODUCTION TO ICONOGRAPHY

persons, or objects, has an ICONCLASS code (figure 52). In ICONCLASS itself there are, therefore, no references to particular works of art; the user must fill it with material.

Art-historical institutions and documentation centers, museums, and print collections may use ICONCLASS to catalogue their works iconographically or arrange their photographs and reproductions by subject. In an ideal situation, works of art that share subjects would possess the same ICONCLASS code. Iconographers everywhere could then procure material in the shortest time possible. Published indices of pictorial resources that have been included in ICONCLASS could also be utilized extensively.

The situation was formerly very different. Researching an iconographical question in a print collection, for example, would usually yield little or no information. Searching through an entire collection could take months. If collections were made accessible through ICONCLASS, one would only need to check under a specific code and, within several minutes, the "iconographical card index" would locate all references to relevant works in the collection. Several institutes in Holland, Germany, the United States, and elsewhere are already working with ICONCLASS. The first indices with ICONCLASS codes to visual material have already appeared. In all probability, this system will soon become the basis for a new method of iconographic research.

How is this system actually constructed? First of all, Professor van de Waal divided the subjects and objects in the visual arts into nine main thematic groups:

1. Religion and Magic
2. Nature
3. Human Being, Man in General
4. Society, Civilization, Culture
5. Abstract Ideas and Concepts
6. History
7. Bible
8. Literature
9. Classical Mythology and Ancient History

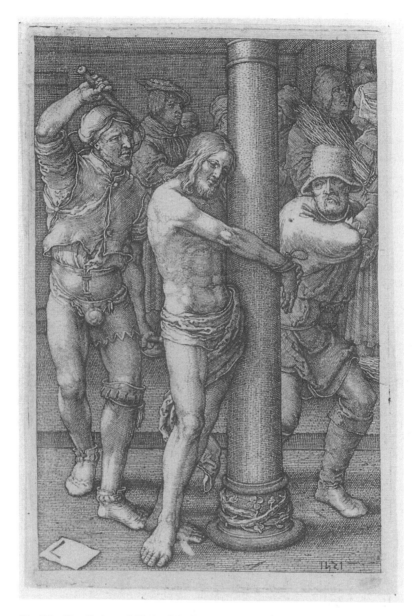

53 The Flagellation of Christ (Matthew 27: 26; Mark 15:15; John 19:1). Copper engraving by Lucas van Leyden.

An Introduction to Iconography

The first five groups include general subjects and artistic concepts, while the remaining four deal with specific themes in the visual arts that usually refer to literary sources. A short overview of material in various ICONCLASS groups can be found in the appendix (p. 143).

ICONCLASS codes are constructed systematically. The code for "The Flagellation of Christ" (figure 53), 73 D 35 1 (pronounced seventy-three-D-thirty-five-one) can be deconstructed thus:

7	=	Bible
73	=	New Testament
73 D	=	Passion of Christ
73 D 3	=	Christ's arrest, trial, and torture
73 D 35	=	tortures of Christ
73 D 35 1	=	flagellation by soldiers, Christ usually tied to a column

Figure 52 also includes some of the system's sub-notations on the theme of "Christ's Flagellation."

A comprehensive *General Alphabetical Index* (3 volumes, around 1500 pages) that contains all subjects under one or more relevant keywords helps ICONCLASS users find their way through the system (figure 54). This alphabetical index can also function as a research tool in cases when subject of an image is unknown. Take, for example, the following scene: a woman with a sword beheads a man who is lying on a bed (figure 55). In order to find the pertinent story, one must only look up keywords such as *beheading, bed, sword,* or *killing* to find references to the subject: Judith and Holofernes. The *General Alphabetical Index* of ICONCLASS is the largest iconographical corpus of the visual arts ever published.

In addition to the system's seven volumes and its three volumes of alphabetical index, there is an extensive seven-volume bibliography for the system's seven volumes. This bibliography—unsurpassed among its kind—contains references to iconographically interesting books, articles, and excerpts from handbooks arranged according to ICONCLASS (figure 56). The ICONCLASS bibliography offers the iconographer the luxury of quickly locating art-historical and cultural-historical literature on themes, object, symbols, activities, and the like. One can only hope

122 Van Straten

Flaccus (Fulvius)

Flaccus (Fulvius)
death of T. Jubellius Taurea: he courageously kills his wife and children,
and finally himself, before the tribunal of Fulvius Flaccus, to show that
he prefers to die rather than benefit from the clemency of the Senate
98 B (JUBELLIUS TAUREA, T.) 68
the erstwhile enemies, Marcus Aemilius Lepidus and Fulvius Flaccus meet and
embrace when they are elected to serve together as censors
98 B (LEPIDUS, M.A.) 51
flag
see also banner
flag, colours (as symbol of the state, etc.) 44 A 3
ruler honoured with flags 44 B 13 3
flag raising 45 B 33 41
flag lowering 45 B 33 42
saluting with flag 45 B 41 3
saluting the flag 45 B 41 4
decorative use of flags, etc.; dressing of ship 45 B 53
(military) flags and standards 45 D 1
flags (~ signalling) 46 E 41
flag-bearer
see standard-bearer
flagellant(s)
flagellants 11 Q 31 32
flagellantism
flagellantism ~ sexual perversities 33 C 89 11
flagellation
see also scourging
castigation, flagellation ~ ascetic life 11 Q 31 3
column (of the flagellation) ~ instruments of the Passion 72 D 82 (COLUMN)
flagellation by soldiers, Christ usually tied to a column see 73 D 35 1
flagellation of Andrew 73 F 25 33
Flagello di Dio
'Flagello di Dio' (Ripa) 11 A 31
flail
agricultural implements (with NAME) 47 I 15 (. . .)
flambeau
see torch
flame(s)
see also fire
see also flaming heart
see also flaming sword
see also torch
Holy Ghost represented as a dove (in flames) 11 E 1
Holy Ghost represented as flames 11 E 2
the seven gifts of the Holy Ghost represented as seven flames 11 E 52
attributes of St. Antony Abbot see 11 H (ANTONY ABBOT)
attributes of St. Ignatius of Loyola see 11 H (IGNATIUS)
attributes of St. Januarius see 11 H (JANUARIUS)
attributes of St. Lambert see 11 H (LAMBERT)
St. Nicholas appears to pilgrims who had received a flask of oil from the
devil (or Diana) disguised as a pious woman; they pour the oil into the
sea whereupon it bursts into flames 11 H (NICHOLAS) 83 3
attributes of St. Vincent Ferrer see 11 H (VINCENT FERRER)
attributes of St. Brigid see 11 HH (BRIGID)
attributes of St. Christina see 11 HH (CHRISTINA)
attributes of St. Clare see 11 HH (CLARE)
attributes of St. Lucy see 11 HH (LUCY)
St. Odilia, kneeling down in prayer, releases the soul of her father, duke
Attich, from purgatory; an angel pulls the duke out of the flames, while
devils try to draw him back 11 HH (ODILIA) 51

530

54 A page from the General Alphabetical Index of ICONCLASS.

An Introduction to Iconography

55 Judith Beheading Holofernes, from the Apocryphal Book of Judith 13. Painting by Jan de Bray.

124 VAN STRATEN

that supplemental volumes of this bibliography will be published before long.

After this general information on ICONCLASS, it is appropriate to present theoretical and practical examples of the system at work.

The Theoretical Application of ICONCLASS

Next we will clarify the steps necessary for working with ICONCLASS. We have included a sketch of the process in diagram 2.

To learn about the subject of any artwork, even if we already know something about it, we first need to collect as much information as possible from iconographical literature, comparable artworks, and literary sources.

Our first step is to study the representation and then think of one or more pertinent keywords. This process resembles the pre-iconographical description of the three-part iconography procedure we discussed in the first chapter (see page 16). As soon as we have found some keywords, we should look them up in the *General Alphabetical Index* of ICONCLASS, where we will usually find the subject in question and the corresponding ICONCLASS code. Thus ICONCLASS indicates the second level of iconographic meaning: the iconographical description.

We can then verify whether the notation is an accurate description of the representation. In many cases, the system offers additional subgroups for certain themes and materials. For example, an image of the Virgin Mary with the Christ-child (figure 57) can lead us to search under the keyword *Madonna* in the *General Alphabetical Index,* yielding a reference to the code 11 F 4. The system has no fewer than three pages of sub-notations and variants, among them standing Madonnas, sitting Madonnas, and certain traditional types of Madonna representations. The system then reveals that the exact code number for the work of art under investigation is 11 F 42 22: "Mary sitting or enthroned, with the Christ-child sitting on her left knee." The angels crowning Mary correspond to code 11 G 23: "Angels crowning."

The correct code number discloses a range of possibilities for collecting additional basic information. To locate iconographically inter-

Diagram 2

The collection of basic material for iconographic research
with the help of ICONCLASS

126 VAN STRATEN

73 D 35 tortures of Christ

73 D 34 4 Judas' punishment in hell
Réau II (2) 443

73 D 35 tortures of Christ
Donati, Miniatura, 588 s.v. Gesù percosso
J. Marrow, 'Circumdederunt me canes multi': Christ's tormentors in Northern European art of the late middle ages and early renaissance, *Art Bull.* 59(1977)167–181
W. H. Beuken, Passietonelen en middeleeuwse volksdevoties, Fs. Cornelis Gerrit Nicolaas de Vooys, Groningen 1940, 9–19
B. Bagatti, Il museo della flagellazione in Gerusalemme, Gerusalemme 1939

73 D 35 1 flagellation by soldiers, Christ usually tied to a column
Donati, Miniatura, 572 s.v. Flagellazione di Cristo – Kirschbaum II 127 – Knipping (2nd ed.) 523 s.v. Flagellation of Christ – Réau II (2) 451 – Schiller II 76
L. Borgo, New questions for Piero's 'Flagellation', *Burl. Mag.* 121(1979)546–553
T. Gouma-Peterson, Piero della Francesca's Flagellation. An historical interpretation, *Storia dell'arte* (1976) No. 28, 217–233
M. Aronberg Lavin, Piero della Francesca: The Flagellation, [London 1972]
M. Aronberg Lavin, Piero della Francesca's 'Flagellation': the triumph of Christian glory, *Art Bull.* 50(1968)321–342
P. Murray, A note on the iconography of Piero della Francesca, Fs. Ulrich Middeldorf, Berlin 1968, 175–179
B. Bruni, La Sacra Colonna della flagellazione in Santa Prassede, *Capitolium* 35(1960)No. 8, 15–19
A. de Leiris, Manet's 'Christ scourged' and the problem of his religious paintings, *Art Bull.* 41(1959)198–201
M. Meiss, The case of the Frick Flagellation, *Journ. Walters Art Gall.* 19/20(1956–1957) 43–63
M. Schapiro, On an Italian painting of the flagellation of Christ in the Frick collection, Fs. Lionello Venturi, Roma 1956, I 29–53
C. Gilbert, On subject and not-subject in Italian renaissance pictures, *Art Bull.* 34(1952)202–216 (i.p. 208)
E. H. Gombrich, Piero della Francesca, *Burl. Mag.* 94(1952)176–178 (see also Idem, *Journ. Warburg Inst.* 22(1959)172)

~ typology

BP, Cornell 98 (No. 36) (Achior is tied to a tree 71 U 33 31; the princes cast Jeremiah into a dungeon 71 O 76 62 6), 295 (the law of the forty stripes 12 A 27 (Deut. 25:2–3): 44 G 37 3; the princes smite Jeremiah 71 O 76 62 6), 295 (Cain kills Abel 71 A 82; death of the seven Maccabean brothers and their mother 71 Z 36); 295 (Lamech beaten by his wives 71 B 15 21; flagellation of Job by his wife 71 W 53 1) – CC, RDK III 846:87 (Jeremiah is tortured 71 O 76 62 2; Achior is tied to a tree 71 U 33 31) – SHS, Breitenbach 182 (Achior is tied to a tree 71 U 33 31; Lamech beaten by his wives 71 B 15 21; flagellation of Job by his wife 71 W 53 1)

56 A page from the ICONCLASS Bibliography, volume 7.

An Introduction to Iconography 127

esting literature, for example, we may look under the same code in the ICONCLASS bibliography. In the system volumes, small marks on the right border indicate notations for literature appearing in the bibliography. When there are no bibliographic references for a specific code, higher code numbers in the system hierarchy can usually lead to relevant references. For example, a lack of iconographically interesting literature under 11 F 42 22 should direct us to 11 F 42.

There are usually further references to secondary literature and source material in the books and essays listed in the ICONCLASS bibliography. The *R.I.L.A.* and the *B.H.A.* contain recent publications not yet listed in the ICONCLASS bibliography. In both the *R.I.L.A.* and the *B.H.A.* there are partially iconographical key word indices, which are incomplete when compared to the ICONCLASS bibliography.

In addition to the specific iconographical literature, we need to learn about everything that has been written on the work of art we are investigating.

We can easily obtain pictorial material on the research subject by consulting a photo archive arranged according to ICONCLASS. Several indices of visual material arranged according to ICONCLASS are already available. In the more specialized and larger photo archives and indices, the chances are naturally greater for finding useful material.

After collecting the material for our iconographic investigation, we can start on the iconographical phase to determine whether the artwork possesses a consciously incorporated deeper meaning.

ICONCLASS can generally save the iconographer a great deal of time, particularly in regard to the often lengthy and troublesome search for material.

A Practical Example

As an example of ICONCLASS in practice, based on diagram 2, imagine being confronted by a picture and not knowing what it represents (figure 58). Our goal is to ascertain its subject and to collect as much material on it as possible. The artist and present location of the picture are unknown, but these are not iconographical problems and need not concern us here.

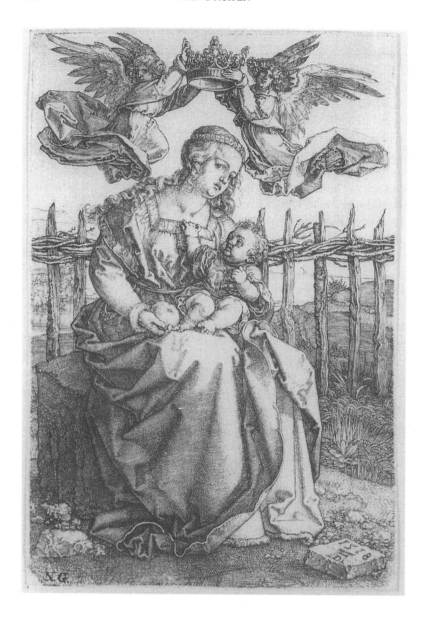

57 Madonna Crowned by Angels. Copper engraving by Albrecht Dürer.

An Introduction to Iconography

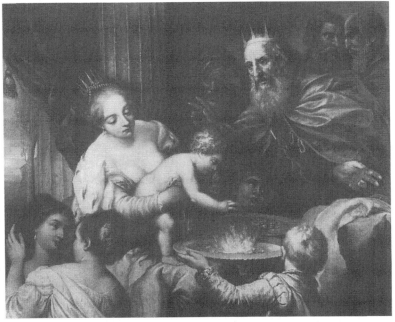

58 The Judgment of Moses. Painting by an unknown master.

We must first examine the picture and formulate a short pre-iconographical description of the picture: e.g., a queen or princess standing before a king with a small child in her arms. This child — it could be a little boy — stretches out its arms toward two large plates being offered by young servants. On one plate lie gold coins; on the other, something is burning. In the background, we see three men, one of whom is attentively following the action, while in the foreground there are two women.

According to our procedure, we must now find several keywords in order to use the ICONCLASS *General Alphabetical Index*. We can distill these keywords from the pre-iconographical description: *king, queen, dishes* (or *plates*), *fire, coins,* and *infant* (or *child*) immediately come to mind. *Choice* might also be pertinent if we assume that the child must choose between the contents of the two plates. When we look up *king* and *queen* in the alphabetical index, we find nothing that corresponds to the subject of the picture. Checking under *plates, fire,* and *choice,*

130 VAN STRATEN

however, uncovers an interesting entry:

> Moses' trial by fire: when given the choice between two plates, one
> containing burning coals, the other a ruby ring (or cherries), Moses
> chooses the burning coals and puts them in his mouth.
> 71 E 11 27 11

Even though several details of this ICONCLASS description do not
correspond exactly to the picture, there can be no doubt that the expla-
nation is relevant. With the help of ICONCLASS, we have found the
iconographical description. It should be clear from this example that it
is often not important to know the subject of a representation. As soon
as we have found the code of our subject, 71 E 11 27 11, we can look it
up in the system. Further sub-groups or variants on the subject might
appear there, although that is not the case with this example. An aster-
isk indicates that we are not dealing with a biblical story but with a
legendary variant of the story of Moses. Furthermore, a mark on the
right-hand border indicates that we can find references to literature on
this subject in the ICONCLASS bibliography. Under the same code,
71 E 11 27 11, we can locate references in the bibliography to Pigler
(chapter 6, A-2) and Réau (B-2).

Pigler mentions nine works of art with the subject "The Judgment
of Moses" and designates the *Speculum Humanae Salvationis* as its liter-
ary source (cf. p. 91). The subject does indeed appear in the *Speculum*,
although in combination with another legend about the young Moses,
in which he tramples on Pharaoh's crown. In the *Speculum*, one of the
most important typological works of the late Middle Ages, the legend
serves as a type for the "Massacre of the Innocents." Both Moses sto-
ries also appear earlier in the *Historia Scholastica* by Peter Comestor
(ca. 1175).

Réau recounts the legend of "The Judgment of Moses" in greater
detail. In Réau's account, one of Pharaoh's high officials dreams that
he sees Moses obtaining Pharaoh's crown. The minister advises Pha-
raoh to have Moses murdered, but another courtier suggests putting
him on trial. It therefore comes to pass that young Moses must choose
between two things: burning coals and a ring with rubies (or cherries
or gold, as in our representation). Of course, Moses takes a glowing
piece of coal and burns his mouth with it, thus explaining why he says

"but I am slow of speech, and of a slow tongue" in Exodus 4:10. Unfortunately, Réau confuses his references to the works of art on this subject with the legend of Moses trampling Pharaoh's crown. While Peter Comestor combines the two stories and both appear in the *Speculum*, the story of trampling Pharaoh's crown comes from a much older source, Flavius Josephus' *Jewish Antiquities*. Both stories are more often represented individually than together in post-medieval art.

In addition to the literature on the subject listed by the ICONCLASS bibliography under 71 E 11 27 11, we can also look for more general literature about Moses. At 71 E 1-4 we might acquire further information on the subject in question.

In addition to searching through iconographical literature, we can also find visual material in photo-collections and indices of works of art arranged according to ICONCLASS. For example, through this approach I discovered several representations of the Moses theme that Pigler and Réau fail to list and that exist in the ICONCLASS photo collection of the Department of Art History in Leiden.

Having demonstrated that ICONCLASS can make available basic material for further iconographic research, we can now consider the possibilities for research in many institutions made possible by ICONCLASS. Following this discussion, we will briefly glimpse into the future of ICONCLASS.

ICONCLASS Applications

ICONCLASS has recently become more popular in The Netherlands, Germany, and several other countries. People agree that that the system is well suited for processing large amounts of visual material, especially by computer. Data banks that are iconographically accessible through ICONCLASS codes and that contain descriptions of artworks are already being compiled. Microfiche and video-disc formats have accelerated the procurement of art historical pictorial materials. Now under development are computer data banks that store pictures in digital form and on CD-ROM.

Among these developments is the ICONCLASS Browser, an automated version of the ICONCLASS System and Alphabetical Index. With

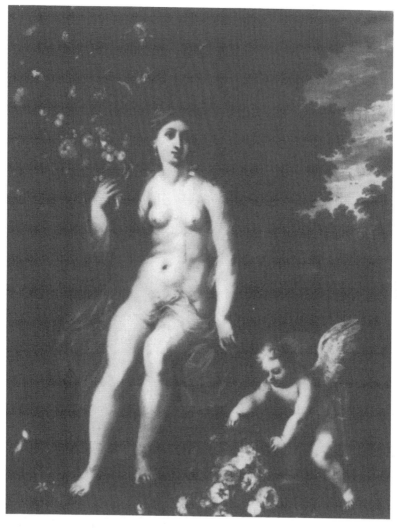

59 Photo card from *D.I.A.L.*

AN INTRODUCTION TO ICONOGRAPHY 133

the Browser, developed at the University of Utrecht, the user may search for ICONCLASS codes and their textual correlates by means of keywords, notations, or a combination of them. The Browser may be linked to documents on works of art and/or electronically-stored visual material. For example, users in Utrecht have applied the Browser to a set of Dutch printers' devices in sixteenth- to eighteenth-century books in the Royal Library in The Hague. We can expect the Browser to become an important tool for iconographic documentation and research in the future.

Users of ICONCLASS can currently choose several ways to search for materials:

1. The first publication based on ICONCLASS was *D.I.A.L.* (*Decimal Index of the Art of the Low Countries*). *D.I.A.L.*, which Germans occasionally call the "Haager Index," is a collection of about 15,000 photos, primarily of paintings, from sixteenth- to eighteenth-century Dutch art. The photos are numbered according to ICONCLASS (figure 59). This edition of the *Rijksbureau voor Kunsthistorische Dokumentatie* (*R.K.D.*) in The Hague originated through a collaboration with the ICONCLASS Division of the Department of Art History at the University of Leiden. *D.I.A.L.* is used worldwide in almost one hundred institutes.

2. Since 1983 the most important example of the application of ICONCLASS is the iconographical indices of the *Marburger Index*. The Bildarchiv Foto Marburg in Marburg an der Lahn, the most important photo archive in Germany, has published a microfiche edition of the abundant photographic resources of German art in collaboration with the Rhenish Photo-Archive in Cologne and other institutions and museums. The *Marburger Index* is available worldwide at some 200 institutions, and contains around 150,000 pictures from the visual arts as well as many architectural photographs.

 Until 1990 two new microfiche-sets were published every year. Microfiches are transparencies (105 x 148 mm) that normally consist of 98 image fields (fig. 60). Microfiche can be viewed through a microfiche reader or projected on the wall as slides; with the

134 Van Straten

60 Microfiche from the *Marburger Index*.

AN INTRODUCTION TO ICONOGRAPHY 135

help of a reader-printer, one can even make photocopies of them.

Computers help produce the indices of the *Marburger Index*, including the iconographical indices of ICONCLASS. The data bank can handle fairly difficult questions such as: "In which biblical representations (contained in the data bank) does the statue of a god from classical mythology appear?" or "Which Dutch artists who also worked in Italy produced drawings of Saint Jerome in the years between 1620 and 1630?"

By the end of 1992, the data bank contained almost 120,000 pictorial descriptions. The indices are published cumulatively on microfiche, and each new installment appears annually. A clear disadvantage of the *Marburger Index* is the lack of uniformity among the material. Because of the variety of data available, such as information about countries, epochs, and various artistic genres like painting, book illuminations, and sculpture, it is difficult to obtain a complete answer to any question. One discovers material only by chance. It is also annoying to work with microfiche.

For some years the Bildarchiv has been cooperating with a number of major museums in Germany. These museums index parts of their holdings along the systematic principles developed in Marburg, including the use of ICONCLASS.

Literature:

[L. Heusinger], *Marburger Index: Inventory of Art in Germany. Users' Manual*, München 1985[2].

This manual is published in German as well. A comprehensive handbook to the *Marburger Index* and the indexing system that was developed for this project is *MIDAS. Marburger Informations-, Dokumentations- und Administrations-System. Handbuch*, by L. Heusinger (München 1989).

3. A project corresponding to the *Marburger Index* is now operating at the Witt Library of the Courtauld Institute in London. The resources of the photo archives of the Witt Library contain some 1.3 million representations from the visual arts, including paintings, drawings, and engravings. The collection is published on microfiche, but only a few copies exist. One copy outside of London is located in the Bildarchiv Foto Marburg; in the United

136　VAN STRATEN

7　Bible

71 E 12 54 1　the gathering of manna
- B.　XIV 10,8; TIB 26,17 (Agostino Veneziano [Musi])
- B.　XVI 119,4(I); TIB 32,159 (Giovanni Battista Franco): The Israelites gathering manna <*71 E 12 54 1* / 31 A 23 (+89)>
- B.　XVI 119,4(II); TIB 32,160 (Giovanni Battista Franco): The Israelites gathering manna <*71 E 12 54 1* / 46 C 12 15>
- B.　XV 113,5; TIB 28,209 (Giulio Bonasone, 1546, after Polidoro da Caravaggio): Moses telling the Israelites to gather the manna and Moses striking the rock <71 E 12 63 / *71 E 12 54 1*>
- B.　XV 300,38; TIB 30,54 (Enea Vico, 1542, after Perino del Vaga): Sacrifice <*71 E 12 83* / *71 E 12 54 1*>*

71 E 12 63　Moses strikes the rock twice in front of the assembled people and water gushes out
- B.　XVI 119,3; TIB 32,158 (Giovanni Battista Franco)
- B.　XV 466,2; TIB 31,305 (Gaspar Reverdino, 1531): Moses striking water from the rock <*71 E 12 63* / 42 A 3 : 42 A 41 1>
- B.　XVI 118,2; TIB 32,157 (Giovanni Battista Franco): Moses drawing water from the rock <*71 E 12 63* / 47 I 21 11 1>
- B.　XV 113,5; TIB 28,209 (Giulio Bonasone, 1546, after Polidoro da Caravaggio): Moses telling the Israelites to gather the manna and Moses striking the rock <*71 E 12 63* / 71 E 12 54 1>

71 E 12 83　Jethro offers a sacrifice to God
- B.　XV 300,38; TIB 30,54 (Enea Vico, 1542, after Perino del Vaga): Sacrifice <*71 E 12 83* / 71 E 12 54 1>*

71 E 13 43　Moses receives the tables of the law from God
- B.　XVI 237,67; TIB 32,380 (Giovanni Battista Fontana, 1569): Mount Sinai <25 H 11 : 61 D (MOUNT SINAI) : 61 D (MOUNT AARON) / 11 P 31 51 / *71 E 13 43*>

71 E 33 22 1　Phinehas follows Zimri and Cozbi and drives his spear through both of them
- B.　XIV 14,14; TIB 26,23-24 (manner of Marcantonio Raimondi, after Giulio Romano?, and copy): The deaths of Zimri and Cozbi, the Midianite <*71 E 33 22 1* : 33 C 41>

71 F 37 61　Samson's hairlocks are cut off by Delilah
- B.　XVI 294,26; TIB 33,149 (Jacopo Palma [Giovane])

71 F 83 51 1 (+3)　the statue of Dagon in Ashdod falls down (angel present)
- B.　XVI 120,6; TIB 32,162 (Giovanni Battista Franco)

71 H 14 43 1　david beheads Goliath (with the Philistines in flight pursued by the Israelites)
- B.　XIV 12,10; TIB 26,19 (Marcantonio Raimondi after Raphael)
- B.　XV 379,6; TIB 31,13 (Giovanni Battista Ghisi [Scultori], 1540, after Giulio Romano)

71 H 14 5　David with Goliath's head
- B.　XIV 12,11; TIB 26,20 (Marcantonio Raimondi, after Raphael?)
- B.　XIV 13,12; TIB 26,21 (Marcantonio Raimondi): David and the head of

471

61　Page from the ICONCLASS Indexes: Italian Prints, volume 2.

An Introduction to Iconography 137

States, there is a copy at the Getty Center for the History of Art and the Humanities in Santa Monica, California. In a special automated, experimental project that makes available 20,000 works of the American School, ICONCLASS organized the iconographic access. A second project on the British School is in progress. In the future we assume that ICONCLASS will be used for iconographic access to all of the Witt Library holdings.

Literature:

J. Sunderland, "The Witt Library-Getty Project," *Art Libraries Journal* 8:2 (1983), 27-31.

J. Sunderland & C. Gordon, "The Witt Computer Index," *Visual Resources* 4:2 (1987), 141-51.

4. Some collections of reproductions in The Netherlands arranged according to ICONCLASS are:

a. Leiden, Photo archives of the ICONCLASS Division in the Institute for Art History. The collection includes some 70,000 representations and specializes largely in Dutch art, emphasizing themes in classical mythology and history. The collection is growing fast.

b. Amsterdam, Photo archives of the Institute for Art History at the Free University. This collection includes about 80,000 representations.

c. The Hague, Iconography Division in the Rijksbureau voor Kunsthistorische Documentatie. A small collection arranged roughly according to ICONCLASS.

5. For several years a series of ICONCLASS *Indexes* has appeared as a supplement to the seventeen ICONCLASS volumes. The first four volumes in this series offer a comprehensive iconographical access to Italian prints from about 1450 to 1700 (figure 61). Approximately 11,000 engravings and etchings from this period have been catalogued by A.M. Hind in *Early Italian Engraving*, and by A. Bartsch in *Le Peintre-Graveur*. Almost all these prints are reproduced in *The Illustrated Bartsch*.

138 VAN STRATEN

The four index volumes are:

R. van Straten, *ICONCLASS Indexes: Italian Prints.*

Early Italian Engraving. Volume 1. Doornspijk 1987.
Marcantonio Raimondi and His School. Volume 2. Doornspijk 1988.
Antonio Tempesta and His Time. Volume 3. Doornspijk 1987.
The Seventeenth Century. Volume 4. Doornspijk 1990.

For an article on the *Italian Prints Indexes,* see R. van Straten, "Indexing Italian Prints with ICONCLASS," *Visual Resources* 7 (1990), 1-27.

Among other volumes planned are a comprehensive index to Friedländer's *Early Netherlandish Painting* by Y.D. Frossati-Okayama and a series on Dutch prints by R. van Straten, of which the first volume, *Hendrik Goltzius and His School,* will be published in 1994.

6. The Fine Arts Library of Harvard University in Cambridge, Massachusetts, one of the largest photo archives in the world, intends to publish a series of iconographical indices to their own collection. The first volumes, listing paintings with biblical themes, have already appeared:

> H. Roberts, *Iconographic Index to Old Testament Subjects Represented in Photographs and Slides of Paintings in the Visual Collections, Fine Arts Library, Harvard University,* New York 1987.

> In 1992 the first volume of the *Iconographic Index to New Testament Subjects,* covering New Testament subjects and focusing on paintings of the Italian School, appeared as:

> H. Roberts & R. Hall, *Italian School Narrative Paintings,* New York 1992.

The second volume, on Italian School Devotional Paintings, is forthcoming.

7. ICONCLASS is used with the *Provenance Index* of the J. Paul Getty Center in Santa Monica, California, to access the subjects of paintings mentioned in old inventories from Italy, Holland, and Spain. The first volume of *Italian Inventories* covers Nea-

An Introduction to Iconography 139

politan inventories and includes a comprehensive iconographic access according to ICONCLASS: G. Labrot, with the assistance of A. Delfino, *Collections of Paintings in Naples 1600-1780,* (Münich [1991]).

Now that we have the ICONCLASS system at our disposal, what can we expect from iconography in the future? First, we can solve many iconographical problems, which means that we can determine the correct subject of many artworks, especially drawings and prints. Second, it will probably become increasingly easy to provide iconographical interpretations. By continually storing iconographical knowledge with the help of ICONCLASS, making retrieval ever more successful, scholarly results will keep improving as well. It is easy to imagine that by means of an ICONCLASS index we will have access to all emblems, to all German copper engravings of the fifteenth and sixteenth centuries, to all scenes from classical mythology occurring in Dutch literary works between 1550 and 1650, and to . . . (diagram 3). If such a development should take place in the near future, as is very probable, one can imagine what an enormous quantity of material would come together here— all arranged according to subject, and possibly further subdivided by country and epoch. Iconographical research will be significantly improved, an exceedingly positive prospect. Beyond these advances, the time art historians and other researchers need to prepare their basic material for iconographic research will be much reduced, and they can devote the hours and days they save to acquiring deeper and more far-reaching insights. Literature and history might thereby play a greater role in the iconographic perspective. Perhaps the growing use of ICONCLASS may represent the dawn of "iconology"—which we defined as a branch of cultural history—based upon a more sophisticated level of iconographical knowledge than has previously existed.

Diagram 3

The Role that ICONCLASS Could Play in the Further Development of Iconography

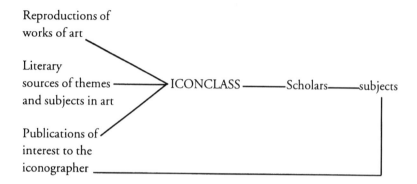

Literature for Further Study — ICONCLASS

N.B. An ICONCLASS handbook will be published in 1994: R. van Straten, *Iconography. Indexing. ICONCLASS. A Handbook*. This publication will include detailed directions for the use of ICONCLASS, a list of corrections and new notations, and a history of ICONCLASS, among other subjects.

1. H. van de Waal, *ICONCLASS: An Iconographic Classification System*. Ed. L.D. Couprie (a.o.). 7 volumes *System*, 7 volumes *Bibliography*, 3 volumes *General Alphabetical Index*. Amsterdam 1973-1985.

 For a general introduction to ICONCLASS, see *System* 2/3: ixff. A more extensive ICONCLASS handbook should appear in 1994 (see van Straten above).

2. L.D. Couprie, "Iconclass: An Iconographic Classification System," *Art Libraries Journal* 8:2 (1983), 32-49.

 A good article, with examples of the structure of the system and its practical use. A somewhat earlier article is: Idem, "Iconclass: A Device for the Iconographic Analysis of Art Objects," *Museum* 30 (1978), 194-8. See also

AN INTRODUCTION TO ICONOGRAPHY 141

R. van Straten, "Panofsky and ICONCLASS," *Artibus et Historiae* 13 (1986), 165-81.

3. H. van de Waal, "Some Principles of a General Iconographical Classification." In *Actes du Cinquième Congrès International d'Esthétique*. Amsterdam 1964, rpt. La Haye 1968, 728-33.

 One of the earliest publications about ICONCLASS, in which Van de Waal elucidates his ideas.

4. J. Becker, "Iconclass . . ." (Book review), *Simiolus* 9 (1977), 45-7.

 An interesting review of the first three volumes of ICONCLASS to be published (bibliography and system).

5. For a comprehensive report on an ICONCLASS workshop that took place in 1987, during which representatives of the most important institutes that actively use ICONCLASS (Witt Library and *Marburger Index*, among others) exchanged experiences and discussed problems, see C. Gordon, "Report on the ICONCLASS Workshop, November 2-4, 1987," *Visual Resources* 5:3 (1988). In 1989 a second workshop focused on automated retrieval with ICONCLASS; for a report see H. Brandhorst & P. van Huisstede, "Report on the ICONCLASS Workshop, June 26-28, 1989," *Visual Resources* 8:1 (1991).

6. For the ICONCLASS Browser see J. van den Berg (a.o.), *ICONCLASS Browser* [Utrecht 1992]. The first part of this booklet is a Browser user's guide, while the second part deals with the use of ICONCLASS.

APPENDIX

An Overview of the ICONCLASS System

AN INTRODUCTION TO ICONOGRAPHY

OUTLINE

I		RELIGION AND MAGIC	II Q	the worship of God
			2	(private) prayer
10		(symbolic) representations	62	pilgrimage
		~ creation, cosmos, etc.	71 2	church
			73	divine service
II		Christian religion	73 2	the seven sacraments
II B		the Holy Trinity	II R	the life of man
			5-7	'Vanitas'
II C		God the Father		
			II U	Last Judgement
II D		Christ		
			II V	the Acts of Mercy
II F		the Virgin Mary		
	2	Mary (without Christ-Child)	12	non-Christian religions
	4	Madonna	12 A	Jewish religion and culture
II G		angels	12 B-U	non-Christian religions and cults
II H		male saints		
			13	magic, supernaturalism, occultism
II HH		female saints		
II I		prophets, sibyls, etc.	14	astrology
	1	prophets		
	2	sibyls		
	6	persons from the Old Testament	2	NATURE
			21	the four elements
II K		devils and demons		
			23	time
II M		the Virtues		
			23 K	labours of the months
II N		the Vices		
			24	the heavens
II P		the Church (as institution)		
	31 11	pope	24 C	planets
	31 12	cardinal		
	31 13	bishop	25	earth
	31 5	monastic orders, monastic life	25 A	maps, atlases

2

25 F	animals	31 F	Death (symbols and personifications)
25 FF	fabulous animals		
25 G	plants	32	human types; peoples and nationalities
25 H	landscapes	33	relations between individual persons
25 I	city view, landscape with man-made constructions	33 A	non-aggressive relationships
25 L	allegories of cities	33 B	aggressive relationships
26	meteorological phenomena	33 C	relations between the sexes
3	HUMAN BEING, MAN IN GENERAL	34	man and animal
31	man in a general biological sense	4	SOCIETY, CIVILIZATION, CULTURE
31 A	the human figure		
31 A 2	anatomy	41	material aspects of daily life
21	skeleton		
23-26	postures and gestures	41 A	housing
31 A 3	the senses	41 B	heating and lighting
31 A 4	disabilities, deformations, etc.	41 C	nutrition, nourishment
44	monstrosities	41 D	fashion, clothing
45	monsters of mixed human and animal shape	42	family, descendance
31 B	mind, spirit	42 A	procreation, birth, etc.
1	sleeping	42 D	betrothal and marriage
31 D	human life and its ages	42 E	burial rites
31 E	death		
23	violent death	43	recreation, amusement

AN INTRODUCTION TO ICONOGRAPHY

147

Outline

43 A	festivities		46 C	traffic and transport
42	triumphal entry		13 1	horseman, rider
43	triumphs (allegorical and symbolical)		24	sailing-ship, sailing-boat
43 1	'Trionfi' (of Petrarch)		47	crafts and industries
43 C	sports, games, etc.		47 B	handicrafts and industries
11	hunting			
12	fishing		47 H	textile industry
9	dancing		47 I	agriculture, cattle-breeding, horticulture, etc.
44	state			
			48	art
44 A	symbols of the state		48 A 98	ornaments
44 B	government, the State		48 C	the arts
11 2	emperor		1	architecture
11 3	king		2	sculpture
			24	piece of sculpture
44 G	Law and jurisprudence		5	painting, drawing, etc.
45	warfare; military affairs		51 3	portrait of painter
			7	music
			9	literature
45 D	insignia; division of armed forces		93	portrait of writer
			49	education, science and learning
45 H	battle, fighting			
45 K	siege, positional warfare		49 C	science
			3	scholar, philosopher
46	social and economic life, transport and communication		49 E	science and technology
			49 G	medicine
46 A	communal life			
14	farmers		49 K	historical disciplines
15	the poor		49 L	writing and letters
46 B	trade; commerce and finance		49 N	reading

4

148 VAN STRATEN

Outline

5	ABSTRACT IDEAS AND CONCEPTS	82	literary characters
		86	proverbs and sayings
51 H 42	Abundance		
		9	CLASSICAL MYTHOLOGY AND ANCIENT HISTORY
52 A 6	Truth		
54 F 12	Luck, Fortune, Lot		
		92	gods and goddesses
59 B 32	Fame		
		92 B	the great gods of Heaven
59 C 2	Justice	1	Jupiter
		3	Apollo
6	HISTORY	4	Mars
		5	Mercury
61 A	historical events and situations		
		92 C	the great goddesses of Heaven
61 B	male historical persons	2	Minerva
		3	Diana
61 BB	female historical persons	4	Venus
61 D	geographical names (not of cities)	92 D	lesser divinities of Heaven
		1	Cupid
61 E	names of cities and villages	4	Muses
61 F	names of historical buildings, etc	93	meetings and dwellings of the gods
7	BIBLE	94 - 95	the Greek heroic legends
71	Old Testament	96	Roman gods and legends
73	New Testament	97	metamorphoses
73 B	birth and youth of Christ	98	classical history
73 D	Passion of Christ	98 B	male persons from classical history
8	LITERATURE		
		98 C	female persons from classical history
81	literary cycles		

5

NAME AND SUBJECT INDEX

Abstractions 25
Ab urbe condita 54, 90
Aeneid 89, 91, 98
Alciatus, A. 29, 60, 62, 63, 70, 71
Allegorical program 41
Allegory chapter 3, and 53
Allen, D.C. 98
Alpers, S. 14
Apocrypha 77, 81
Appuhn, H. 98
Ariosto, L. 95
Arntzen, E. 102
Attribute 48, 51

Bal, M. 22
Bartsch, A. 137
Bätschmann, O. 22
Beazley, J.D. 111
Becker, J. 35, 141
Bellori, G.P. 19
Berefelt, G. 67
Berg, J. van den 141
B.H.A. 101, 127
Bialostocki, J. 21
Bible 77, 79, 98
Biblia Pauperum 77, 79, 98
Biedermann, H. 71
Bildarchiv Foto Marburg 113, 133, 135
Boas, G. 71
Boccaccio, G. 28
Brandhorst, H. 141
Brown, C. 55
Browser (ICONCLASS) 131, 141
Bryson, N. 22
Burn, L. 111

Camerarius, J. 65
Carpenter, T.M. 111
Cartari, V. 28, 35
Cassidy, B. 23

Cats, J. 64. 65
Chateaubriand, F.A.R. 19
Comestor, P. 130
Concordantia Caritatis 79, 98
Conti, N. 28, 35
Couprie, L.D. 44, 140
Crowell 111

Daly, P.M. 62, 70
Dante Alighieri 95
Davidson, G. 110
Deubner, L. 34
Devices 59, 60
D.I.A.L. 132, 133
Drake, M. & W. 109

Eberlein, J.K. 22
Eco, U. 22
Emblems 57 *ff.*
Epigrams 57
Esmeijer, A.C. 113

Fasti 54, 88
Flavius Josephus 79, 131
Frenzel, E. 105, 106
Frossati, Y.D. *see* Okayama, Y.

Garnier, F. 115
Genre Painting 55, 62
Giehlow, K. 71
Giovio, P. 60
Golden Legend see *Legenda Aurea*
Gombrich, E.H. 22
Gordon, C. 137, 141
Graves, R. 111
Guarini, B. 98

Haager Index 133
Hall, J. 101
Hall, R. 138
Heckscher, W.S. 70, 113

150 VAN STRATEN

Heidt, R. 22
Held, J. 43
Henkel, A. 68, 103, 105
Hennecke, E. 109
Herder Symbol Dictionary 71
Hermerén, G. 22, 45, 67
Heroides 88
Heusinger, L. 135
Hieroglyphs 29, 59
Hind, A.M. 137
Hinks, R. 44
History painting 75
Holl, O. 35
Homer 88, 90
Horapollo 29, 59, 71
Huisstede, P. van 141
Hyginus 89, 95

ICONCLASS chapter 7, and 20, 101
 see also Waal, H. van de
 overview of the system 145 *ff.*
Iconographical description 4, 6, 14,
 124, 130
Iconographical interpretation 4, 10, 14
Iconographic Reference books
 chapter 6
 Christian iconography 106 *ff.*
 General Reference books 102 *ff.*
 Profane iconography 110 *ff.*
Iconography, Theory of chapter 1
 Panofsky 20
Iconologia see Ripa, C.
Iconology; Iconological interpreta-
 tion 4, 12, 15
Iliad 88, 98
Index of Christian Art 113
Institut für mittelalterliche Realien-
 kunde 114
Inventaire Général 114
Inventory of American Paintings 114

James, M.R. 109
Jameson, A.B. 110
Jongh, E. de 62, 70
Jöns, D.W. 70

Kaemmerling, E. 21
Kaftal, G. 109
Kaute, L. *see* Lüdicke-Kaute, L.
Kautzsch, E. 107
Kirschbaum, E. 104, 106, 107
Kunstpatrimonium 114

Labrot, G. 139
Landwehr, J. 70
Leeman, F.G.W. 71
Legende Aurea 79, 85, 86
Lempriere 111
Lessing, G.E.19
Libman, M. 21
Libraries 112 *ff.*
Literary sources chapter 5
 Religious subjects 77 *ff.*
 Classical subjects 88 *ff.*
 Post-classical profane subjects 93 *ff.*
Livy 54, 90
Lüdicker-Kaute, L. 35, 44, 67
Lurker, M. 106

Mâle, E. 34, 35
Mander, K. van 88
Mandowsky, E. 35
Marburger Index 133 *ff.*
Marle, R. van 110
Meditationes Vitae Christi 79
Metamorphoses see Ovid
Miedema, H. 36

Odyssey 88, 90, 98
Ohlgren 109, 110
Okayama, Y. [Frossati-] 36, 138
Ovid 88, 92, 93, 94, 98
Ovide Moralisée 88, 90

Panofsky, E. 20, 21, 67
Pauper's Bible see *Biblia Pauperum*
Personification chapter 2
Petrarca, F. 38
Photo archives 112 *ff.*
 –ICONCLASS 133 *ff.*
Picinelli, F. 48
Pigler, A. 105, 130 *ff.*

Plutarch 89
Poschat, G. 67
Porteman, K. 70
Portrait *see* Personification
Praz, M. 68
Pre-iconographical description 4, 14,
 124, 149
Provenance Index 138

Rainwater, R. 102
Réau, L. 67, 106, 130
Reid, J.D. 112
Répertoire d'Art et d'Archéologie 101
Rijksbureau voor Kunsthistorische
 Documentatie (R.K.D.) 112
R.I.L.A. 101, 127
Ripa, C. 29, 35, 43
Roberts, H. 138
Rochelle, M. 112
Rollenhagen, G. 65
Roscher, W.H. 34, 111
Rudolph, H. 14

Sayles, H.M. 68
Schaper, E. 67
Schiller, G. 107
Schneemelcher, W. 109
Schöne, A. 68, 70, 103, 105
Schreiner, R. 107
Seigneurer, J.C. 99
Semiology; Semiotics 20
Septuagint 77
Seznec, J. 34
Sluijter, E.J. 98
Speculum Humanae Salvationis 79, 98,
 130

Stössl, F. 34
Straten, R. van 22, 138, 140, 141
Sunderland, J. 137
Symbol chapter 4
Symbolic representation 53 *ff.*

Tasso, T. 95, 97
Tervarent, G. de 108, 110
Thieme, U. 102
Triumph 38, 40
Typology 77 *ff.*

Vaenius *see* Veen, O. van
Valerius Maximus 89
Veen, O. van 39, 65, 68
Virgil 89
Visscher, R. 65, 69
Volkmann, L. 71
Volp, R. 67
Voragine, J. de 79
Vulgate 77

Waal, H. van de 35, 68, 98, 117, 141
Walle, R. van de 114
Wappenschmidt, H.-T. 44
Warburg, A. 20, 67
Warburg Institute 20, 102, 113
Wentzel, H. 67
Werner, G. 35
Winckelmann, J.J. 43
Wirth, K.A. 70
Witt Library 113, 135, 137, 141
Wittkower, R. 67
Woodruff, H. 113
Wright, F.A. 111